American Material Culture and the Texas Experience
Itinerant and Immigrant Artists and Artisans in 19th-Century Texas

The David B. Warren Symposium

Volume 4

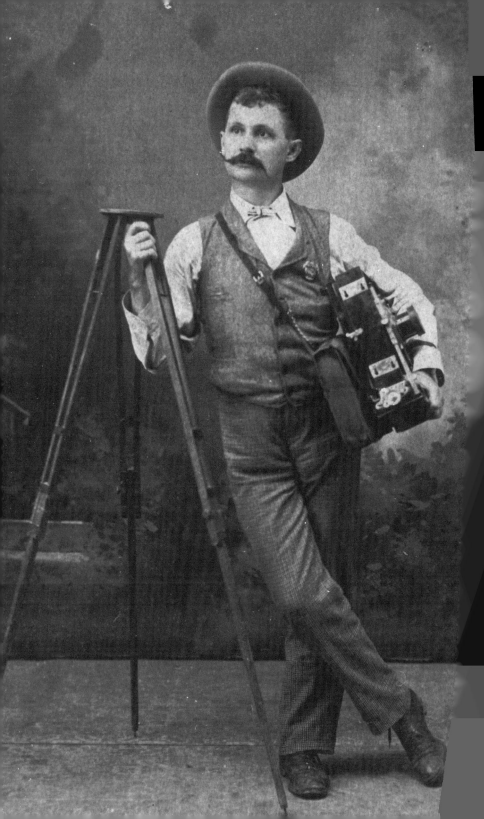

American Material Culture and the Texas Experience
Itinerant and Immigrant Artists and Artisans in 19th-Century Texas

The David B. Warren Symposium

Volume 4

Bayou Bend Collection and Gardens
The Museum of Fine Arts, Houston

Publications Director: Diane Lovejoy
Edited by Melina Kervandjian
Book design by Marisa Avelar
Printing by Masterpiece Litho, Inc.

Printed in the United States of America

Library of Congress Cataloging-in-Publication Data

David B. Warren Symposium (4th : 2013 : Museum of Fine Arts, Houston)
American material culture and the Texas experience : itinerant and immigrant artists and artisans in 19th-century Texas.
pages cm

"This publication is based on papers delivered at the fourth David B. Warren Symposium, "Itinerant and Immigrant Artists and Artisans in 19th-Century Texas," presented by Bayou Bend Collection and Gardens at the Museum of Fine Arts, Houston, on October 25–27, 2013."
Includes bibliographical references.
ISBN 978-0-89090-180-9 (softcover)
1. Art, American--Texas--19th century--Congresses. 2. Decorative arts--Texas--History--19th century--Congresses. 3. Itinerant artists--Texas--Congresses. 4. Immigrants--Texas--Congresses. I. Bayou Bend Collection. II. Title.
N6530.T4D38 2013
704'.08691209764--dc23
2014018044

Front cover: John Woodhouse Audubon, lithography by John T. Bowen, **Texian Hare (Lepus Texianus),** *1848, hand-colored lithograph, the Museum of Fine Arts, Houston, the Bayou Bend Collection, gift of Bennie Green in memory of her husband, Joe M. Green, Jr., B.2009.17.*

Back cover: Adolph Kempen, Austin, Texas, **Desk,** *1870–80, walnut, maple, and pine, the Museum of Fine Arts, Houston, the Bayou Bend Collection, gift of William J. Hill, B.2012.38.*

Frontispiece: Fey & Braunig Studio, **Henry J. Braunig,** *c. 1890, private collection.*

The 2013 David B. Warren Symposium at Bayou Bend received generous funding from:
The David B. Warren Symposium Endowment
Bobbie and John Nau
William J. Hill
Humanities Texas, the state affiliate of the National Endowment for the Humanities
The Summerlee Foundation
Marilyn Lummis
Nancy Glanville Jewell
Texas Historical Foundation
Friends of the Texas Governor's Mansion
Jane Karotkin

If you would like to support the Endowment Fund for the biennial David B. Warren Symposium, please send your contributions to Bayou Bend Collection and Gardens, P. O. Box 6826, Houston, Texas 77265-6826.

Contents

Foreword

Because of its isolation from the national rail network, local artisanship flourished in nineteenth-century Texas. Skilled craftsmen provided citizens with their household needs until the late 1870s, and created a heritage of beautiful objects in the process.

— Lonn Taylor, Texas historian and curator

Lonn Taylor, noted authority on the architecture, furniture and decorative arts of nineteenth-century Texas and the American Southwest, seemed the ideal person to help set the stage for my foreword to this volume which focuses on artists and artisans working in nineteenth-century Texas, who during that era were for the most part either itinerants or immigrants. Lonn was also the logical choice because of his long connection to Bayou Bend through his relationships with both Ima Hogg and David B. Warren, including producing with them the seminal 1975 publication, *Texas Furniture: The Cabinetmakers and Their Work*, which came about because of Miss Hogg's encouragement of increased scholarship in the field of early Texas decorative arts.

During a nine-year (1957–66) transformation of Bayou Bend—her home and collection—into a public museum, Ima Hogg ensured that, along with rooms featuring masterpieces of seventeenth- to nineteenth-century American decorative arts and paintings, there would be one space—which she called The Texas Room—devoted to her native state. At that time, Texas material culture scholarship was very limited; it was thought there were few craftsmen working in Texas, and thus the room contained Southern furniture reflecting the heritage of many early settlers in the eastern half of the state. Thanks to scholarly advances over the subsequent five decades and the generosity of Bayou Bend donors, The Texas Room today is comprised primarily of important examples of nineteenth-century Texas-made furniture [such as a desk by German-born, Austin-based craftsman Adolph Kempen (back cover)], decorative arts, and paintings.

Ima Hogg was correct and visionary in championing Texas material culture within the broader field of American material culture. She was equally spot-on when in 1965

Ima Hogg and David B. Warren at Bayou Bend, 1971.

she selected David B. Warren to serve as the first curator of Bayou Bend, writing shortly after his arrival, "I feel that Bayou Bend is going into the right hands…." During his thirty-eight-year tenure (1965–2003) at the Museum of Fine Arts, Houston, David served as curator of the Bayou Bend Collection, associate director of the Museum, and director of Bayou Bend Collection and Gardens. In recognition of his interests in American material culture and special scholarship in Texas decorative arts, in 2003 the Museum established a biennial symposium devoted to "American Material Culture and the Texas Experience," and named it in his honor. As founding director emeritus of Bayou Bend, David remains a wise and generous colleague and an important link to Ima Hogg.

I know that David would support my acknowledging here the important part played by another curator at Bayou Bend in the impressive development of our Texana collection, Michael K. Brown, who died in 2013. Hired by David in 1980 as associate curator, Michael spent the next thirty-three years devoted to the Bayou Bend Collection, and lately had focused much of his time on nineteenth-century Texas decorative arts, building our collection with the generous support of collector William J. Hill and helping to set up the William J. Hill Texas Artisans and Artists Archive. Over time, this digital archive will build a searchable database on nineteenth-century Texas artists and craftsmen and cement Bayou Bend's position as a leading resource for the study of Texas material culture.

This publication contains the revised and expanded proceedings of the fourth biennial David B. Warren Symposium, held at the MFAH on October 25–27, 2013. The topics were selected to support the 2013 symposium theme, "Itinerant and Immigrant Artists and Artisans in 19th-Century Texas." By publishing the proceedings of each symposium, the Museum seeks to promote scholarship in—as well as increase awareness of—the material culture of pre-1900 Texas (and when relevant to that year's theme, the lower South and the Southwest), placing the region within the broader field of American material culture. With the presentation of this fourth volume of our on-going series, I am pleased to announce a new partnership that will increase exponentially our ability to disseminate the wealth of information and new scholarship presented at each symposium: with its Fall & Winter 2014 catalog, Texas A&M University Press will begin distributing the book series, including the previous three volumes.

Volume 4 begins with the symposium's Opening Address, a primer by Ron Tyler on the development of the arts in nineteenth-century Texas that provides readers with a helpful historical and cultural context for the following papers which address specific art or artisan subjects. Mario L. Sánchez explores borderland heritage and the cultural continuity between South Texas and Northern Mexico by focusing on the South Texas built environment. D. Jack Davis shares seminal research in the relatively neglected field of early Texas silver and silversmiths. David Haynes turns a scholarly eye to early photographers in Texas, showing how their images preserve information about our history and heritage. The essays conclude with Heather Elizabeth White's study of artist Thomas Allen, an academically trained painter based in Boston who traveled several times to Texas between 1877 and 1879, sketching and painting in and around San Antonio and Galveston.

The presentation of the 2013 symposium was due in large part to the talents and hard work of Bayou Bend's programs manager Joey Milillo and visitor services manager Lavinia Ignat; they were ably assisted by many other Bayou Bend and museum staff members. However, the symposium would not have been possible without proceeds from the symposium endowment and additional generous support from Bobbie and John Nau; William J. Hill; Humanities Texas, a state partner of the National Endowment for the Humanities; The Summerlee Foundation; and Marilyn Lummis. Nancy Glanville Jewell; Texas Historical Foundation; Friends of the Texas Governor's Mansion; and Jane Karotkin also deserve special acknowledgment.

Thanks to the invaluable contributions of these generous supporters and the important work of the symposium participants, we celebrate another successful event and publication that broadens our understanding of Texas material culture, and we look forward to continuing to honor Miss Hogg's vision for the role of Bayou Bend in preserving and understanding the region's heritage within the context of our nation's heritage.

Bonnie A. Campbell
Director
Bayou Bend Collection and Gardens

The Arts in Early Texas: A Cultural Crossroads

Ron Tyler

To say that the development of art in nineteenth-century Texas was slower than that of the rest of the country is a truism, but, as with most truisms, simply accepting this statement without delving deeper limits our understanding of the subject. By examining the development of art in Texas, we can gain insights into the eventual establishment of artistic communities in all the major cities of the state by the end of the century, especially if we consider three significant events as turning-points: the establishment of Austin's colony beginning in 1821, the subsequent Texas Revolution in 1836, and annexation to the Union in 1846—and compare them to what was going on in the United States at the same time. These were major steps in the development of Texas, and in the initial nurturing of a culture in which artists could survive if not prosper. And to properly appreciate their accomplishments, modest as they are, perhaps we need to be reminded of the harsh conditions under which they labored.

In the summer of 1825, the United States was a young country enmeshed in cultural experimentation and discovery, a developing nation in the process of defining itself. That process took a major step forward in the fine arts when the little-known English émigré Thomas Cole traveled up the storied Hudson River on a sketching

Detail, fig. 24

*Fig. 1. Thomas Cole, **Indian Pass**, 1847, oil on canvas, the Museum of Fine Arts, Houston, museum purchase with funds provided by the Agnes Cullen Arnold Endowment Fund, 95.138.*

trip. Awed by the "magnificence and grandeur" of the Adirondack Mountains and charmed by the "ever changing... color, light and shadow" along Catskill Creek, the young artist sketched as if in a trance. He returned to his rented attic room in New York City, eager to transfer the "perfect beauty" that he had seen to canvas. The results, shown in the window of a neighborhood frame shop, attracted the attention of the elderly John Trumbull, beloved painter of the American Revolution, who hurried to the studio of his friend, the artist and critic William Dunlap, to explain that, "This youth has done what I have all my life attempted in vain."[1]

Just as Americans were trying to define themselves, especially in terms of literature and the arts, Cole embraced Nature—a subject in harmony with the expanding country and the developing philosophies of the foremost American thinkers of the day, Ralph Waldo Emerson and Henry David Thoreau—and he embarked on an illustrious career as the delineator of the American landscape. He exhibited in New York galleries, where, in comparison to today, a larger percentage of the population viewed art exhibitions, and artists enjoyed steady patronage, propelling landscape painting into the preeminent form of art in this country for most of the nineteenth century. Cole inspired the first American movement in painting, known as the Hudson River School, and today examples of his work can be found in major collections

*Fig. 2. F. W. Seiders, **Antonio López de Santa Anna**, daguerreotype, San Jacinto Museum of History, Houston.*

around the country, including the Museum of Fine Arts, Houston (fig. 1).[2] In other words, Cole and his colleagues helped foster a "native" school of American art, which became a part of America's developing identity—a part of the cultural luggage, if you will, that many future immigrants would bring with them to Texas. Moreover, all of these artists nourished a growing appetite for American scenes, assisted in part by the lithographic presses based in the larger cities—New York, Philadelphia, Boston, Baltimore, New Orleans—which soon made it possible for even modest families in every region of the United States to own images of their own country and culture as well as copies of great works of art.[3]

One of the first Anglo artists to venture into Texas, Major J. Strange, perhaps a descendant of a South Carolina family of Scottish descent, had arrived in Texas and made his way, possibly as a member of the Texian army, to Orozimbo plantation, nine miles northwest of present-day Angleton, where the new government was holding two of the most important prisoners taken at the battle of San Jacinto, the now-depressed Mexican General Antonio López de Santa Anna and his aide, Colonel Juan N. Almonte. Strange apparently volunteered to paint their portraits. He also intended to paint a portrait of General Martín Perfecto de Cos, who was being held on Galveston Island. Strange apparently envisioned creating a series of

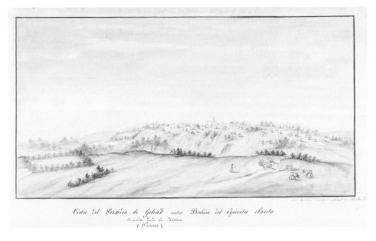

Fig. 3. Lino Sánchez y Tapia after Jean Louis Berlandier, **Vista del Presidio de Goliad antes Bahía del Espiritu Santo, Tomada desde la Mission (Texas)**, *c. 1834, Yale Collection of Western Americana, Beinecke Rare Book and Manuscript Library.*

portraits based on Santa Anna's imprisonment partly based on the model established by those artists who had painted Napoleon's exile. In an interview with the *Telegraph and Texas Register*, he described this anticipated project (which ultimately resulted in only two known works) as the "Longwood" of Texas, a reference to the place of Napoleon's imprisonment on Saint Helena. Both Santa Anna and Stephen F. Austin provided Strange with letters attesting to the accuracy of the general's portrait, and Strange showed it in various cities in the United States before both the painting and the artist disappeared from the historical record (Perhaps Strange's portrait of Santa Anna resembled a daguerreotype—which would have reversed the original image—of what appears to be an oil painting, now in the collection of the San Jacinto Museum of History, Houston) (fig. 2).[4]

Strange's fate and fall into obscurity in many respects paralleled the status of the arts in the early days of the new Texas Republic and help to illustrate the cultural and economic divergence between Texas and the more settled areas of the country in this period, for few of the early Texas settlers had time or inclination to practice or encourage the arts in any fashion. Unlike the states along the eastern seaboard and the Mississippi and Ohio rivers, Texas was still a sparsely-settled region in 1824 and would have a conflicted western border until 1881. As the nineteenth-century historian Frederick Jackson Turner would observe, those pioneers had a "masterful grasp of material things," but were noticeably "lacking in the artistic."[5]

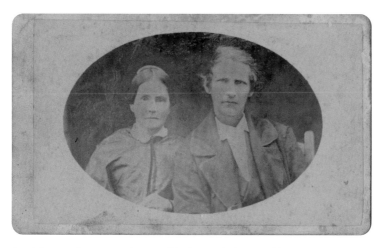

Fig. 4. H.R Marks, **Portrait of Mary Rabb**, *photograph of Mary Rabb and an unidentified man, possibly her husband, Rabb (Mary) Family Papers, The Dolph Briscoe Center for American History, The University of Texas at Austin.*

Two of the "first ladies" of Texas art history apparently agreed. Frances Battaile Fisk, an active clubwoman and civic leader in Abilene who in 1928 wrote *A History of Texas Artists and Sculptors*, explained that "Texans of earlier generations were too occupied with the development of material resources . . . to have any leisure for the enjoyment of beauty."[6] Author and poet Esse Forrester-O'Brien of Waco, who wrote *Art and Artists of Texas* in 1935, put it even more bluntly: "Art is especially slow where scalping is in style."[7]

Texas had been New Spain's far northern frontier, and, while the Spanish jealously defended it, they did little to develop it, especially after the murderous attack in 1758 by Indians of several different tribes on the outpost at Mission San Sabá in West Texas.[8] The Spanish firmly established the ranching culture in the settlements along the Rio Grande in the mid-eighteenth century. But by the second decade of the nineteenth century, there were still only about 3,000 residents in the modest villages at Nacogdoches, San Antonio, and La Bahía (Goliad), which were still reeling from the first Texas revolution in August 1813, when a Spanish royalist troop led by General Joaquín Arredondo destroyed the rebel force of 1,400 Mexicans, Anglo-Americans, and Indians at the battle of the Medina—still the bloodiest battle fought on Texas soil (fig. 3). The combined assaults of filibusters, insurgents, royal armies, and hostile Indians had left the country destitute. Nacogdoches was virtually a ghost town, and only the two settlements along the San Antonio River valley, San Antonio

> D. B. A. G. T. T.— The sheriffs of Mississippi now put on a few additional letters to the legal writs they are obliged to return. Where a fellow has run away, sloped, they now write the following significant letters upon the back of the writs —D. B. A. G. T. T., which being interpreted, means "Done Bursted and Gone to Texas!"

Fig. 5. Newspaper clipping featuring the popular nineteenth-century phrase "Gone to Texas," Times-Picayune *(New Orleans), August 13, 1839.*

and La Bahía, had begun to recover. It is no wonder that Stephen F. Austin, when he first saw the land in the summer of 1821, thought it to be a "wild, howling, interminable solitude from Sabine to Bexar."[9]

Still, Austin's determination and enthusiasm grew as he set out to fulfill his father's dream of establishing an Anglo-American colony in Spanish Texas, even in the wake of Mexican independence from Spain in 1821. While many Americans hesitated as the pall of the Panic of 1819 spread throughout the nation, others were willing to begin life anew in Texas, especially as it became widely known that cheap land was available, even if it meant that they would be moving far from the centers of population and commerce. One must remember that in 1822 nothing traveled faster than a horse, and even as late as 1830, Texas was still almost three weeks travel time from New York City and Philadelphia, the cultural centers of the country, and a week from New Orleans. Even as late as 1857, Central Texas was still a week away from New Orleans and its amenities.[10]

Settlers in Austin's colony, at best, faced isolation on the frontier and crude and sometimes dangerous living conditions. The isolation was expected, but sometimes the bleak conditions were a surprise. Mary Crownover Rabb, who arrived as a young woman with her husband, John, in 1823, settled in what is today La Grange (fig. 4). "But thare was no house thare then nore nothing but a wilderness, not even a tree cut down to mark that plais," she recalled.[11] Noah Smithwick, who arrived in Texas as a nineteen-year-old in 1827, left a vivid memoir of his experience. Passing through DeWitt's colony, he found the inhabitants, "living—if such existence could be called living—huddled together for security against the Karankawas, who, though not openly hostile, were not friendly." Smithwick is perhaps best known for quoting an elderly woman who tersely summarized her experience: Texas was "a heaven for men and dogs, but hell on women and oxen."[12]

Immigrants came from areas hardest hit by the financial collapse, many of them fleeing debt, some of them avoiding the law, but all looking forward to a

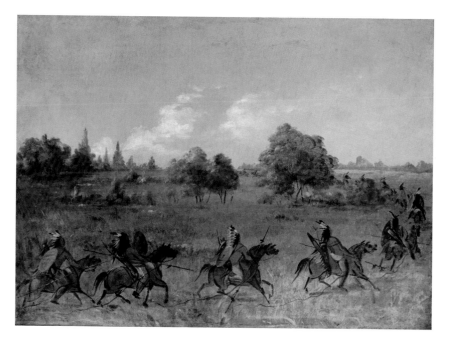

Fig. 6. George Catlin, **Comanche War Party on the March, Fully Equipped***, 1846–48, oil on canvas, Smithsonian American Art Museum, gift of Mrs. Joseph Harrison, Jr., 1985.66.596.*

new start. Some took the time to scrawl "G.T.T." on their doors before leaving, and "Gone to Texas" became a widely used phrase that made its way into editorials and even popular fiction of the day (fig. 5).[13] Some 20,000 Anglo-Americans had arrived by 1828 and 1829, when Mexican General Manuel de Mier y Terán alerted Mexican officials to the "volitile elements" that he had found in Texas while conducting the Comisión de Límites (Boundary Commission), which set out to survey the eastern boundary between Mexico and the U.S. and to observe and report on conditions in the region. Mier y Terán considered the situation in Texas to be dangerous and warned Mexican President Guadalupe Victoria "if timely measures are not taken, Tejas will pull down the entire federation." He felt that this "unmelted pot" of divergent peoples and cultures—Anglo immigrants, native and immigrant Indian, slaves, Tejanos—could be a volatile stew. He recommended that the government recruit more European and Mexican immigrants to offset the continuing migration from the United States and develop trade between the Mexican interior and Texas so that the colonists would not be dependent on New Orleans.[14]

Fig. 7. Photograph of Dilue Rose Harris, probably made after 1900, San Jacinto Museum of History, Houston.

Mier y Terán's report formed the basis for the Law of April 6, 1830, by which Mexico attempted to restrict and control American immigration into Texas. He recommended that the Austin and DeWitt colonies be exempted from the decree, but, in a clear indication of the intent of the law, the next grant, in 1831, to settle 600 non-Anglo families in East Texas went to General Vicente Filisola, a career Mexican military officer. While Texas residents had not been united on any cause prior to the Law of April 6, now they began to feel the stirrings of protest. Austin remained loyal to the government and encouraged his colonists to do so as well, but William H. Wharton claimed that the law,

> Goad[ed] us on to madness, in as much as it blasted all our hopes, and defeated all our calculations; in as much as it showed to us, that we were to remain scattered, and isolated, and unhappy tenants of the wilderness of Texas[15]

The Law of April 6 did not stop Americans from moving to Texas. Among those who arrived after the law was proclaimed were William Barret Travis (1831), Sam Houston (1832), George Childress, who wrote the Texas Declaration of Independence (1835), and David Crockett (1836). The Anglo-American population had grown to about 30,000 by 1836.[16]

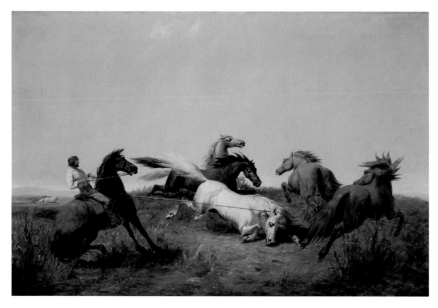

Fig. 8. William Tylee Ranney, **Hunting Wild Horses***, 1846, oil on canvas, Museum of the American West, Autry National Center, Los Angeles.*

Another person who thought momentarily about Texas was the artist George Catlin, who had pioneered with his documentation of the Indian tribes of the upper Missouri River in 1832. In 1834, Catlin accompanied a dragoon troop into Indian territory (Oklahoma), and perhaps even into north Texas, and he later invested in some ultimately unsuccessful speculative schemes involving Texas land. His hundreds of paintings of the Plains Indian tribes now make up a large part of the collection of the Smithsonian American Art Museum (fig. 6).[17]

The events that led to the Texas Revolution are well known, especially Austin's ill-fated trip to Mexico City and his arrest. By the time Austin was released and returned to Texas in September 1835, the colonists, including many recent arrivals, were well on their way to rebellion.[18]

The revolution itself was relatively short—from the attempt by Mexican soldiers to retrieve the cannon at Gonzales in October 1835, to the battle of San Jacinto and the torrential rains that virtually destroyed the remaining Mexican Army in April and May 1836—but the country was devastated in that short time.[19] Both Sam Houston and Santa Anna burned towns as they crossed over the landscape— Gonzales, San Felipe, Harrisburg, New Washington. The fall of the Alamo and Fannin's defeat at Goliad in March 1836, precipitated what became known as the

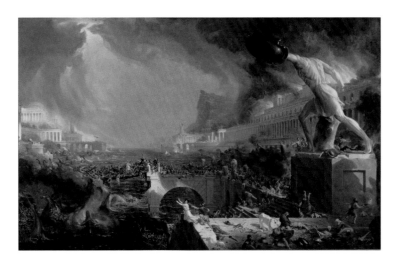

*Fig. 9. Thomas Cole, **The Course of Empire: Destruction**, 1836, oil on canvas, New-York Historical Society, 1858.4.*

"run-away scrape," in which citizens took what they could and turned pell-mell toward the east. Ten-year-old Dilue Rose (fig. 7) remembered her family's flight: "We left home at sunset, hauling clothes, bedding and provisions on the sleigh with one yoke of oxen." When they reached the Lynchburg ferry on the San Jacinto River, they found "fully five thousand people at the ferry. We waited three days before we crossed." On the other side, they struck out across the prairie only to have her uncle's wagon bog down. Her little sister died during the flight, and they had yet to cross the rain-swollen Trinity River.[20] (Not everyone fled eastward; many slaves, recognizing that the Mexican government had abolished slavery in 1829 and that Santa Anna had promised them freedom, ran toward the invading armies.[21])

With the Mexican army in retreat after San Jacinto, Dilue's family returned to its home near the Gulf coast. They found that the Mexican troops had ransacked their house. They chased the hogs that had been let in by the troops from the house and began anew. Even though it was Sunday, Dilue's father immediately began plowing, and her mother started doing the family wash.[22]

There were no artists present to record these scenes. At least one talented painter, William Ranney, was involved in the revolution, but so far as we know, he produced no images of it and did not even paint pictures that derived from his Texas experience until ten years later, when he depicted the capture of the legendary "Great White Steed of the Prairies" as well as various genre scenes of trappers (fig. 8).[23]

Fig. 10–11. **Augustus Chapman Allen** *and* **John Kirby Allen,** *watercolor on ivory, San Jacinto Museum of History, Houston.*

"He was so charmed with everything he saw," Ranney's wife later reported. "Scenes that he long dreamt of were now before his eyes; the wild enchanting prairies, the splendid horses, nature in all her splendor; his poetic mind was filled with the beautiful."[24] The dramatic scenes of the Alamo and the battle of San Jacinto were left to later, post-Civil War artists intent upon creating a visual record of the birth pangs of the Republic of Texas.

In New York in the fall of 1836, Thomas Cole exhibited his series of five paintings entitled *The Course of Empire* to great acclaim (fig. 9). It was a "shot across the bow" of Andrew Jackson's America—a warning that empires come and empires go—that was delivered even before the young United States had really established itself, and while Texas was still struggling to determine its path. Very few Americans who saw the paintings would have missed his point, but in his pessimistic view of history, Cole also intended them to convey universal truth.[25] Cole was thirty-five years old and at the pinnacle of his career. The contrast between art and the cultural environment on the East Coast compared with Texas could hardly have been starker than at this moment.

Sam Houston, the hero of San Jacinto and a good friend of American President Jackson, was overwhelmingly elected president of Texas in the fall of 1836, but the country faced so many problems that Interim President David G. Burnet resigned before the completion of his term in the hope that Houston would be able to better

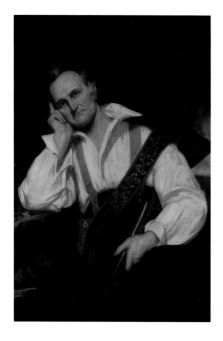

Fig. 12. G. P. A. Healey, **John James Audubon,** *1838, oil on canvas, Museum of Science, Boston.*

Fig. 13. John Woodhouse Audubon, lithography by John T. Bowen, **Texian Hare (Lepus Texianus),** *1848, hand-colored lithograph, the Museum of Fine Arts, Houston, Bayou Bend Collection, gift of Bennie Green in memory of her husband, Joe M. Green, Jr., B.2009.17.*

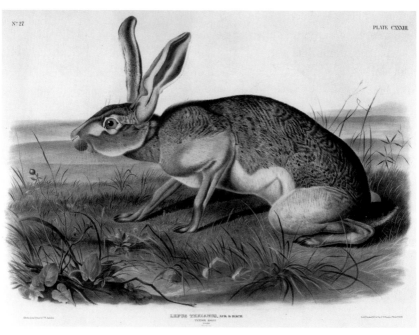

address them. Burnet, for example, had tried to abide by the Treaty of Velasco and permit Santa Anna to return to Mexico, but Thomas Jefferson Green at the head of 130 volunteers from New Orleans prevented his departure, and the Texan government still held the Mexican general when Houston took office. But, compared to the other problems that Houston faced—including possible recognition and perhaps annexation by the United States, organizing a government, preventing the restless and anarchic army from a foolhardy attempt to invade Mexico, and defense against marauding Indians along the western border and any Mexican attempt to retake Texas—Santa Anna was merely a nuisance, dealt with by moving him from the temporary capital at Velasco to Orozimbo plantation to protect him from the rowdy elements of the army. Houston was beset by political factionalism, and the republic was more than a million dollars in debt from the revolution. Harrisburg had been burned, so the temporary capital was set up at Velasco, then moved to Columbia, up the Brazos River. The Indians had not taken part in the revolution, but the raids were sure to return since raiding was an important part of their economic system.[26] Just a few months before, a large number of Comanches and Caddoes had raided Parker's fort, near what is today Groesbeck, killing several and taking five captives, including Cynthia Ann Parker and Rachel Plummer, who would publish a harrowing account of her experience in 1838.[27] These were the conditions under which Major Strange painted the portraits of Santa Anna and Almonte.[28]

In Texas, meanwhile, two of the enterprising developers, the Allen brothers, John and Augustus, placed their bet on their new town ten miles up Buffalo Bayou from Harrisburg, which they named after the president (fig. 10–11). They secured the capital by promising to build a suitable government building (to which they shrewdly retained the title). By New Year's Day 1837, enterprising newcomers had pitched tents on the site of Houston and were conducting business, exhibiting an entrepreneurial precocity for which the city is still known. The largest tent, of course, belonged to the saloon keeper, who reportedly became a rich man.[29] The famous ornithologist and artist John James Audubon, accompanied by his son John Woodhouse Audubon, visited that month, a year after the battle of San Jacinto, in what was his first trip west of the Mississippi River (figs. 12–13).[30] He was finishing his "great work," *The Birds of America*, but needed to see what new species he could find in the great flyway that is Texas. He landed at Galveston and took the *Yellow Stone* up Buffalo Bayou:

Fig. 14. Thomas Jefferson Wright, **Erastus (Deaf) Smith**, 1836, oil on canvas, San Jacinto Museum of History, Houston.

Fig. 15. Thomas Jefferson Wright, **Juan Nepomuceno Seguin**, 1838, oil on canvas, State Preservation Board, Austin, CHA 1989.096.

As soon as we rose above the bank [of the Bayou], we saw before us a level of far-extending prairie, destitute of timber, and rather poor soil. Houses half finished, and most of them without roofs, tents, and a liberty pole, with the capitol. . . . We approached the President's mansion . . . wading through water above our ankles. This abode of President Houston is a small log-house, consisting of two rooms, and a passage through, after the southern fashion. The moment we stepped over the threshold, . . . the ground-floor . . . was muddy and filthy, a large fire was burning, a small table covered with paper and writing materials, was in the centre, camp-beds, trunks, and different materials, were strewed around the room. . . .

"We amused ourselves by walking to the capitol," Audubon recalled, "which was yet without a roof, and the floors, benches, and tables of both houses of Congress were. . . well saturated with water. . . ." After meeting with President Houston, Audubon and his party returned to their "boat through a melee of Indians and blackguards of all sorts" who were camped in groups around the village. As he left

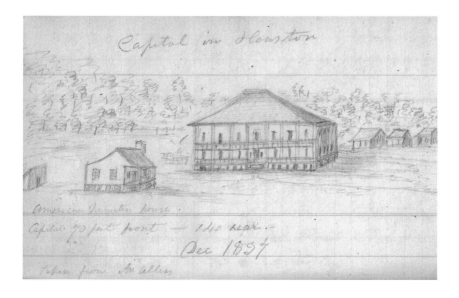

Fig. 16. Mary Austin Holley, **Capitol in Houston**, 1827, The Dolph Briscoe Center for American History, The University of Texas at Austin.

Texas, Audubon wrote that he had not found any new birds, "but the mass of observations that we have gathered . . . has, I think, never been surpassed. I feel myself now tolerably competent to give an essay on the geographical distribution of the feathered tribes of our dear country."[31] Of that other bird, the Raven, Sam Houston's honorary Cherokee name, Audubon wrote, "Our talk was short, but the impression which was made on my mind at the time by himself, his officers, and his place of abode, can never be forgotten."[32]

Although Audubon initially had been shunned in Philadelphia, the monumentality of his accomplishment had won over most of his critics, and his book was now being acclaimed as a "great American Work," a further effort to define the national character. But Audubon, a consummate salesman by now, did not even try to sell a copy of his expensive book in Texas because he knew that no one there had money.

Shortly after Audubon left, Senator Stephen H. Everitt of Jasper introduced a resolution in the Texas Senate on May 25 acknowledging Audubon's "fame, talents, and researches" and recommending that the republic grant him honorary citizenship

so that "Texas may evince to the world that She is, even now, while Struggling for Liberty, ready to foster genius and Talent . . . fully impressed with the importance of promoting Science and research. . . ." The resolution was referred to the Committee on Foreign Relations, where it apparently died with no further action—suggesting that perhaps Texas was not yet ready to "foster genius and Talent."[33]

As Audubon returned to Britain to finish his great book, two other artists came to Houston to seek their fortune. Limner Thomas Jefferson Wright of Kentucky arrived in the spring of 1837, and Ambrose Andrews, a miniaturist and portrait painter, arrived from New Haven, Connecticut, in the fall, enduring a hurricane en route. They immediately set about trying to overcome the seemingly insurmountable hardships of the place and began to paint portraits of Texas heroes. Wright painted Sam Houston, Erastus "Deaf" Smith, Juan Seguin, and others, with the intent of creating a "gallery of National Portraits" similar to what Charles Willson Peale had established in his museum in Philadelphia with his paintings of American revolutionary war heroes (figs. 14–15). Andrews painted Houston, who enjoyed having his portrait made, and former Governor Henry Smith and joined Wright in an exhibition in the capitol in late 1837. We know of it because President Houston gave the writer Mary Austin Holley a tour of the exhibition when she visited in December, and she described it in a letter to her daughter: "in one wing there was a gallery of distinguished characters of the last campaign," she explained. "You see, the arts flourish in this new land already" (fig. 16).[34]

Unfortunately, Holley had overstated the case. In April of 1841, Ambrose Andrews gave up on his Texas experiment after three and one-half years. He placed an ad in the *Telegraph and Texas Register* announcing the exhibition of "a considerable number of pictures that he has painted during his last three years residence in this City" as a farewell salute. He moved to New Orleans, then to St. Louis, and finally back to the East Coast. It is unfortunate that none of his Texas work is known, for he was a good artist, already having painted what is considered his masterpiece, *The Children of Nathan Starr*, about a year before he came to Texas.[35] The editor of *The Morning Star* lamented that, "A new country is certainly not a field promising great success to artists of any kind and more particularly is such a country illy qualified to induce the early immigration of those devoted to the profession of portrait painting."[36] Gail Borden, Jr., and Francis Moore, Jr., publishers of the *Telegraph and Texas Register*, found equally unwelcoming conditions. They moved their press from Columbia to Houston, the new capital. They had arranged with a contractor to build an office, but upon arrival found that they had been swindled. No structure had actually been built, so they rented the "only convenient building obtainable"

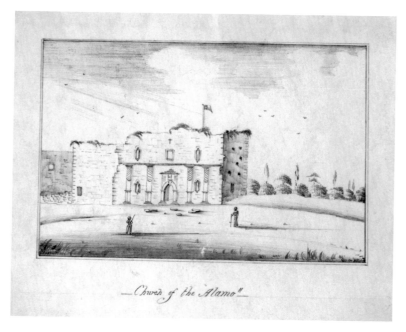

Fig. 17. William Bissett, *The Church of the Alamo*, 1840, pencil on card, courtesy of the Witte Museum, San Antonio, Texas.

and began publication of their newspaper. When the rains came and the temporary roof almost collapsed, the dirt floor turned into "a bed of mud," forcing the next issue of the paper to be late.[37]

It was soon apparent that Houston not only lacked housing and amenities, but it had also been built on a swamp. Mrs. William Fairfax Gray, wife of one of the city's notable lawyers, said that she "never saw anything like the mud here. It is a tenacious black clay which can not be got off of anything without washing—and is about a foot or so deep" (Audubon had similarly written about walking in water more than ankle deep on his way to see President Houston). Add to the mud the carcasses of dead animals that lay where they fell, decaying along with other refuse, horse droppings, and raw sewage. It is no wonder then that Dr. Ashbel Smith asked a New Orleans friend to send him a good "pair of Indian Rubber overshoes."[38]

As the new residents soon discovered, the mud was only one of the numerous problems in building a city on the banks of Buffalo Bayou. During the summer, the swarms of flies were constant and carried the germs of dysentery; mosquitoes carried malaria. Typhus, influenza, cholera, and tuberculosis were common, and yellow fever

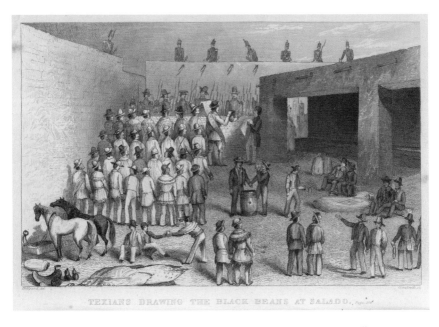

Fig. 18. Charles McLaughlin, **Texians Drawing the Black Beans at Salado**, in Thomas Jefferson Green,
Journal of the Texian Expedition Against Mier; Subsequent Imprisonment of the Author; His Sufferings,
and Final Escape from the Castle of Perote *(New York: Harper and Bros., 1845).*

Fig. 19. William Howard, **Portrait of
Stephen F. Austin**, *1833, watercolor on ivory,
The Dolph Briscoe Center for American History,
The University of Texas at Austin.*

Fig. 20. Attributed to Washington Cooper,
**Sam Houston as Gaius Marius at the Ruins of
Carthage**, *oil on canvas, Harry Ransom Center,
The University of Texas at Austin, 73.640*

seemed to strike every year. Travelers immediately noticed the fleas, which "were as thick as the sands of the sea," according to C. C. Cox, one of the new store clerks. But the rats might have been worse. Gustav Dresel, a young German immigrant, reported in 1838 that "Thousands of these troublesome guests made sport by night, and nothing could be brought to safety from them. . . ." There were so many rats that even the best rat dogs grew tired of chasing them. "Rats often dashed across me by the half-dozens at night," he wrote. "In the beginning this proves annoying; of course, later one gets accustomed to it." Cox confirmed Dresel's comments. "I cannot convey an idea of the multitude of Rats in Houston at that time," he wrote. "They were almost as large as Prairie dogs. . . ."[39]

Further inland, San Antonio, well over a century old in 1837, was located in a far more hospitable environment on the San Antonio River. But San Antonio was close to the frontier and subject to both Indian and Mexican raids. Mary Maverick, the wife of San Antonio's mayor, remembered two 1838 incidents, one in which thirty-eight Comanches approached the edge of town, killing four men and stealing a boy, and another involving 200 Mexican troops crossing the Rio Grande and capturing a supply train transporting retail goods from Copano, north of Corpus Christi, to San Antonio.[40] The response was, as author Edward Stiff observed in his immigrant's guide, that "Every thing denotes a system of defence; the houses are built of stone, . . . with flat roofs, and a parapet or strong wall above the covering, which is pierced for fire arms as well as the walls below." Historian Jesús Frank de la Teja confirms that here, as well, "A rough and dangerous frontier life could hardly be expected to be the medium in which 'high' culture would develop." Nor had things improved much by the time artist and surveyor William Bissett visited while making sketches for Francis Moore, Jr.'s *Map and Description of Texas*, published in 1840 (fig. 17).[41]

On the whole, Texas had not fared well in the skirmishes with Mexico since independence. Even though the United States, Great Britain, France, and the Netherlands recognized Texas independence, Mexico had not relented, actually invading on two different occasions, capturing San Antonio each time. And Texas retaliatory efforts were more than futile; they were disastrous. The Santa Fe expedition of 1841 was a thinly disguised effort to expand Texas jurisdiction to New Mexico, and Mexican troops captured the entire force, along with the editor of the New Orleans *Times-Picayune*, George Wilkins Kendall, without firing a shot, marching them all off to Perote prison. The Mier Expedition of 1842 met a worse fate. In a failed attack on the Mexican village of Mier on the Rio Grande, more than 170

*Fig. 21. Unknown photographer, **Sarah Ann Lillie Hardinge**, c. 1850, daguerreotype with applied color, Amon Carter Museum of American Art Archives, Fort Worth, Texas, gift of Natalie K. Shastid, P1988.26.*

men were captured and forced to draw beans from a jar in a lottery that would determine which of them would be executed. The survivors were housed with some of the Santa Fe prisoners in Perote. One of the prisoners, Charles McLaughlin, was an artist who provided a series of drawings that illustrated Thomas Jefferson Green's *Journal of the Texian Expedition Against Mier…* (fig. 18).[42]

"Thank God, we are now annexed to the United States," Mary Maverick wrote in her journal in July 1845. Annexation marked the third major change for Texas, as it became the twenty-eighth state in the Union.[43] Even though annexation meant war with Mexico, which lasted from 1846 until 1848, statehood brought on another wave of immigration.

Two years after annexation, Thomas Cole died in Catskill, New York. He had been one of the leading proponents of romanticism in the United States. He had only one student, Frederick Edwin Church, who went on to establish an equally successful career, but Cole greatly influenced the work of a number of leading New York artists—Asher B. Durand, John Frederick Kensett, and Sanford Robinson Gifford— who formed the corps of what became known as the second generation of the Hudson River School.[44]

In Texas, meanwhile, a second wave of itinerant limners still experienced only limited success.[45] But it was not lack of appreciation that stymied their efforts, but lack of currency and the difficulty of traveling over roads that were little more than cow trails and that turned into quagmires during the rainy season. Several prominent

Fig. 22. Sarah Ann Lillie Hardinge, **Mr. Polley's Plantation, Harrie's Birthplace,** *c. 1856, transparent and opaque watercolor over graphite on paper, Amon Carter Museum of American Art Archives, gift of Natalie K. Shastid, 1984.3.19.*

citizens of Texas enjoyed having their portraits made, but often had to look outside of Texas for artists to execute their likenesses. Stephen F. Austin, for example, had his portrait painted several times (fig. 19), the last of which was made in 1835–36 when he was in Washington or New Orleans.[46] A number of artists, both painters and photographers, attempted to capture the likeness of Sam Houston, as president of the Republic, as senator, and as governor. One portrait painter in Nashville named Washington Cooper painted Houston dressed as the Roman general and statesman Gaius Marius (fig. 20). Historian James Haley writes,

> It was no accident that Houston had himself painted as Gaius Marius; those who view that toga-wrapped portrait of him as evidence of patrician leanings could use a dose of Houston's own classical training: Gaius Marius rose as a man of the people, who near the end of his life snatched Rome, in the name of the people, from the grip of Lucius Sulla and his abusive senatorial snobs. . . . Houston, like Marius, moved among patricians and, like Marius, had married among patricians. . . [and] like Marius, never befriended them to the detriment of the common citizens.[47]

Fig. 23. Photograph of Karl Friedrich Hermann Lungkwitz, Institute of Texan Cultures, UTSA Libraries Special Collections for the Institute of Texan Cultures, The University of Texas at San Antonio.

Other citizens of the new Republic also liked to have their portraits done, and—despite the sparseness of the population (as late as 1850, Texas had only four towns with more than one thousand in population, and none with more than five thousand)[48]—they would soon be attracted to scenes of different parts of the state as various itinerants, amateurs, surveyor/artists, military officers, and travelers, crisscrossed the state as a part of military expeditions, boundary surveys, railroad surveys, or even independently as just a Sunday sketcher, such as Sarah Ann Hardinge (figs. 21–22).[49] The difficult, frontier conditions, the continued lack of hard currency and, even, the development of daguerreotype photography posed challenges, but presented opportunities for the persistent.[50] There were essentially no located artists in the state until the surge in European immigration in the 1840s and 1850s. Artist and surveyor Theodore Gentilz came with Henri Castro's colony to Castroville; Carl G. Von Iwonski, Karl Friedrich Hermann Lungkwitz, Richard Petri, and

Fig. 24. Karl Friedrich Hermann Lungkwitz, **Guadalupe River Landscape,** *1862, oil on canvas, the Museum of Fine Arts, Houston, the Bayou Bend Collection, gift of Miss Ima Hogg, B.67.39.*

Louisa Wueste arrived with the German migration to New Braunfels, Fredericksburg, and San Antonio; and the French academy-trained Eugenie Lavender immigrated with her husband and lived in various Texas cities before settling in Corpus Christi.[51]

Lungkwitz, who had trained in Düsseldorf, finally brought romantic landscape painting to the state in 1851 (fig. 23). He had arrived with the impression that he could survive "with his art—without humbug," perhaps because of the success of the artists of the Hudson River School, but soon found that he had to take up farming and cattle raising to supplement the meager income from sales of his paintings. He finally resorted to producing lithographs of his painting of Fredericksburg, hoping for multiple, lower-priced sales, but was never able to fully support himself from his art.[52] The romanticism of Lungkwitz's landscapes—a characteristic which demonstrated a kinship with the Hudson River School—is one of the forces that made Texas's cultural assimilation into the Union so easy (fig. 24).[53]

*Fig. 25. Friedrich Richard Petri, **Self-Portrait**, c. 1850, watercolor and pencil, The Dolph Briscoe Center for American History, The University of Texas at Austin.*

Richard Petri had a far shorter career than Lungkwitz because he died prematurely when he drowned in 1857 (fig. 25).[54] Before his death, he was working on what would become his Texas masterpiece, *Fort Martin Scott*, in which he depicted the multi-ethnic Texas frontier (fig. 26). The commander of the post was Brevet Major James Longstreet, and he is pictured in the center of the painting with the Indian woman on his arm. We do not know her identity, but she probably was a member of a group of Lipan Apache Indians who visited Longstreet at the fort. The man with the stovepipe hat standing in the center of the group is George Thomas Howard, the Indian agent. Standing to his left are John Connor and John Taylor, Delaware Indian scouts and interpreters. The man in the red blanket is Jim Shaw, also a Delaware interpreter, and seated in front of him is Jacob Kuechler, trained in engineering and forestry in Germany and married to Petri's sister.

Petri attempts inclusiveness in this painting, as he pictures an old woman at the foot of the tree on the left and a baby, with a ragged shirt that appears to be wings, in the center-foreground. Just inside the teepee opening, he shows a boy trying to take a bone away from a dog, probably a comment upon the poverty of the Indians in the Fredericksburg area, and, at the far right, an Indian drinking

*Fig. 26. Friedrich Richrd Petri, **Fort Martin Scott**, 1850s, unfinished oil on canvas, The Dolph Briscoe Center for American History, The University of Texas at Austin.*

from a bottle in one of the settlers' pockets, again, likely a comment on the Indians' degradation.

By the 1850s, in other words, not only were trained artists depicting Texas scenery and painting portraits, but they were also searching for meaning and struggling to teach in the same tradition as artists on the East Coast and in Europe. The recent immigrants from within the United States brought the legacy of the Hudson River School with them to Texas, applying many of its teachings to interpretations of their new home. As Melinda Rankin, a teacher and Presbyterian missionary wrote, "While we disclaim imaginary paintings and fictitious speculations, we feel justified in the assertion that no country is more eminently favored by nature, both for beauty and excellence, than Texas."[55] Indeed, the union was no longer merely political, as Texans now fully shared in the cultural interests that motivated the rest of the country. The burgeoning post-Civil War years would bring even more talent and diversity to the state arts scene.

Notes

1 William Dunlap, *History of the Rise and Progress of the Arts of Design in the United States* (2 vols.; New York: George P. Scott and Co., 1834), 2: 360. For a discussion of this incident, see Alan Wallach, "Thomas Cole: Landscape and the Course of American Empire," in William H. Truettner and Alan Wallach, eds., *Thomas Cole: Landscape into History* (Washington, D.C.: National Museum of American Art and Yale University Press, 1994), 23–24.

2 See Linda S. Ferber, *The Hudson River School: Nature and the American Vision* (New York: New-York Historical Society, 2009), and James Thomas Flexner, *That Wilder Image: The Painting of America's Native School from Thomas Cole to Winslow Homer* (New York: Bonanza Books, 1962), xi.

3 For a discussion of lithography in the U.S., see Harry T. Peters, *America on Stone: The Other Printmakers to the American People* (Garden City, N.Y.: Doubleday, Doran and Co., 1931), Peter C. Marzio, *The Democratic Art: Pictures for a Nineteenth-Century America: Chromolithography, 1840–1900* (Boston: David R. Godine and the Amon Carter Museum, 1979), and Jay T. Last, *The Color Explosion: Nineteenth-Century American Lithography* (Santa Ana, CA: Hillcrest Press, 2005).

4 *The Telegraph and Texas Register* (Houston), August 2, 1836, p. 2, col. 3, identifies "Major J. Strange" as "an artist from the United States." Pauline A. Pinckney, *Painting in Texas: The Nineteenth Century* (Austin: University of Texas Press for the Amon Carter Museum of Western Art, 1967), 9–11, suggests that he was the James Strange who was a member of Austin's colony, but this is probably not the case. James Strange apparently remained in Texas, while Major J. Strange took his paintings on a tour of various American cities before disappearing from the record. Strange exhibited the portraits at Bank's Arcade in New Orleans (see *New Orleans Bee*, August 24, 1836, p. 2, col. 5) and at the Mississippi Hotel in Natchez in September 1836, where a critical reporter described the portraits in an article in *The Mississippi Free Trader and Natchez Gazette* (Natchez, MS), September 9, 1836, p. 2, col. 1, which was picked up and published in other newspapers, such as the *New-York Spectator*, September 15, 1836, p. 1, col. 4. Strange also exhibited the portraits at the State House in Jackson, Mississippi, and at the Louisville, Kentucky, Museum. See *The Mississippian* (Jackson), October 14, 1836, p. 2, col. 7; and the *Louisville Daily Journal*, November 19, p. 2, col. 2, November 21, p. 2, col. 5, November 26, p. 2, col. 2, and November 28, 1836, p. 2, col. 6. Strange's portrait might have been the source for one of the many images of Santa Anna that appeared separately and in various publications during the 1830s and 1840s. See Kenneth Reuben Durham, Jr., *Santa Anna: Prisoner of War in Texas* (Paris, TX: The Wright Press, 1986), 57–59, for Santa Anna's imprisonment at Orozimbo. Pinckney, *Painting in Texas*, 213, also raised the possibility that the first native-born Anglo-Texan artist was John J. Tucker, who moved to Cincinnati sometime in the 1820s to pursue a career as a portrait, landscape, and genre painter. He was active in Cincinnati from about 1834 to 1839, then returned to Texas in 1840–41 and advertised his services in the *San Luis Advocate*, December 10, 1840, p. 3, col. 4, and subsequently for several months thereafter. See also Mary Sayre Haverstock, Jeannette Mahoney Vance, and Brian L. Beggitt, *Artists in Ohio, 1787–1900: A Biographical Dictionary* (Kent, Ohio: Kent State University Press, 2000), 873.

5 Frederick J. Turner, "The Significance of the Frontier in American History," in *Annual Report of the American Historical Association for the Year 1893*, 53rd Congress, 2nd Session (Washington: Government Printing Office, 1894), 226–27. The Indian wars did not cease in Texas until the Apache Victorio was driven into Chihuahua and killed by the Mexican army in 1880. See Robert M. Utley, *Frontier Regulars: The United States Army and the Indian, 1860–1890* (New York: Macmillan Publishing Co., Inc.,; London: Collier Macmillan Publishers, 1973), 359–65.

6 Frances Battaile Fisk, *A History of Texas Artists and Sculptors* (Abilene, TX: self-published, 1928), 4.

7 Esse Forrester-O'Brien, *Art and Artists of Texas* (Dallas: Tardy Publishing Co., 1935), 4. O'Brien opened her book with the story of the La Salle colonist who was carving a beautiful wooden door for Fort St. Louis only to be "smote" by a Native American before he could finish the job.

8 For information on Mission San Sabá, see Robert S. Weddle, *The San Sabá Mission: Spanish Pivot in Texas* (Austin: University of Texas Press, 1964), and *After the Massacre: The Violent Legacy of the San Sabá Mission* (Lubbock: Texas Tech University Press, 2007).

9 Ted Schwartz, *The Forgotten Battlefield of the First Texas Revolution: The Battle of Medina* (Austin: Eakin Press, 1985). Stephen F. Austin to Mary Austin Holley, November 17, 1831, in Eugene C. Barker ed., *The Austin Papers* (2 vols. and a supplement; Washington, D.C.: Annual Report of the American Historical Association for the Year 1922, 1928), 2: 705.

10 Michael Graham Richard, "How fast could you travel across the U.S. in the 1800s?," http://www.mnn.com/green-tech/transportation/stories/how-fast-could-you-travel-across-the-us-in-the-1800s, accessed January 15, 2014.

11 Fane Downs, "'Tryels and Trubbles': Women in Early Nineteenth-Century Texas," *Southwestern Historical Quarterly* 90 (July 1986), 37–39.

12 Noah Smithwick, *The Evolution of a State, or Recollections of Old Texas Days* (Austin: Gammel Book Company, 1900), 14–16.

13 See, for example, *Niles' Register*, November 8, 1834, p. 147, col. 2; Alice Richmond, "A Tale, in Seven Chapters," *Southern Literary Messenger* V (January 1839): 79; and "The Blind Squatter," in *The Living Age* 8 (January 3, 1846): 18.

14 Jack Jackson, ed., *Texas by Terán: The Diary Kept by General Manuel de Mier y Terán on His 1828 Inspection of Texas*, trans. by John Wheat (Austin: University of Texas Press, 2000), 98.

15 Wharton quote in *Proceedings of the General Convention of the Delegates Representing the Citizens and Inhabitants of Texas*, in H. P. N. Gammel comp., *The Laws of Texas, 1822–1897* (10 vols.; Austin, 1898), 1: 488. For a succinct discussion of the law, see Curtis Bishop, "Law of April 6, 1830," *Handbook of Texas Online* (http://www.tshaonline.org/handbook/online/articles/ngl01), accessed January 13, 2014, published by the Texas State Historical Association.

16 See entries in the *Handbook of Texas Online* for each individual.

17 See William H. Truettner, *The Natural Man Observed: A Study of Catlin's Indian Gallery* (Washington, D.C.: Smithsonian Institution Press and the Amon Carter Museum, 1979). A more recent biography is Benita Eisler, *The Red Man's Bones: George Catlin, Artist and Showman* (New York: W. W. Norton & Company, 2013).

18 The most recent and thorough treatment of Austin is Gregg Cantrell, *Stephen F. Austin: Empresario of Texas* (New Haven: Yale University Press, 1999). The standard is Eugene C. Barker, *The Life of Stephen F. Austin* (Nashville: Cokesbury Press, 1925; rpt., Austin: Texas State Historical Association, 1949; New York: AMS Press, 1970).

19 See Gregg J. Dimmick, *Sea of Mud: The Retreat of the Mexican Army after San Jacinto, An Archeological Investigation* (Austin: Texas State Historical Association, 2004).

20 "The Reminiscences of Mrs. Dilue Harris," *Quarterly of the Texas State Historical Association* 4 (January 1901): 162–63. For the story of the revolution, see Stephen L. Hardin, *Texian Iliad: A Military History of the Texas Revolution* (Austin: University of Texas Press, 1994).

21 See Randolph B. Campbell, *An Empire for Slavery: The Peculiar Institution in Texas, 1821–1865* (Baton Rouge: Louisiana State University Press, 1989), 44.

22 "The Reminiscences of Mrs. Dilue Harris," 177–78.

23 Quoted in "Frontier Yarns," *Putnam's Monthly*, 8 (November 1856), 504. For information on Ranney, see Francis S. Grubar, *William Ranney: Painter of the Early West* (New York: Clarkson N. Potter, Inc./Publisher, 1962); Linda Ayres, "William Ranney," in Ron Tyler, ed., *American Frontier Life: Early Western Painting and Prints* (New York: Abbeville Press, 1987), 79–107; and Linda Bantel and Peter H. Hassrick, *The Art of William Ranney: Forging An American Identity* (Cody, WY: Buffalo Bill Historical Center, 2006). For more on the legendary white horse, see Elizabeth Atwood-Lawrence, "The White Mustang of the Prairies," *Great Plains Quarterly* 1, 2 (Spring 1981): 80–94.

24 Quote is in Bantel and Hassrick, *The Art of William Ranney*, xv. See also Sam DeShong Ratcliffe, *Painting Texas History to 1900* (Austin: University of Texas Press, 1992), for the later scenes of the great moments of the revolution.

25 Quoted in Earl A. Powell, *Thomas Cole* (New York: Harry N. Abrams, Inc., Publishers, 1990), 70.

26 For information on Sam Houston, see James L. Haley, *Sam Houston* (Norman: University of Oklahoma Press, 2002). See also David La Vere, *The Texas Indians* (College Station: Texas A&M University Press, 2004), 180–81.

27 Rachel Plummer, *Rachel Plummer's Narrative of Twenty-One Months Servitude as a Prisoner Among the Comanche Indians: Reproduced from the Only Known Copy* (Austin: The Jenkins Company, 1977).

28 *Telegraph and Texas Register* (Columbia), August 2, 1836, p. 2, col. 3; *The Mississippi Free Trader and Natchez Gazette* (Natchez, MS), September 9, p. 2, col 3, September 16, 1836, p. 3, col. 2; *Louisville Daily Journal*, November 19, p. 2, col. 2, November 21, p. 2, col. 5, November 26, 1836, p. 2, col. 2.

29 Mark E. Nackman, *A Nation Within a Nation: The Rise of Texas Nationalism* (Port Washington, N.Y.: National University Publications, Kennikat Press, 1975), 34–35; Stephen L. Hardin, *Texian Macabre: The Melancholy Tale of a Hanging in Early Houston* (Abilene: State House Press, 2007), 91.

30 John Woodhouse Audubon returned to Texas in late 1845–46 to gather animals for his father's second great book, *The Viviparous Quadrupeds of North America* (two volumes; 1845–46). He had heard of the "jackass" hare, so called because his long ears reminded him of a donkey, and friendly Native Americans provided him with several specimens. The name was quickly shortened to "jackrabbit."

31 Audubon, *The Birds of America, from Drawings Made in the United States and Their Territories* (1870) 4:218, 5:303; Audubon to Thomas M. Brewer, n.p., October 29, 1837, in Herrick, *Audubon the Naturalist* 2:166. Audubon, *Ornithological Biography* 4: xvi–xviii, 58–67, 74–80, 81–87, 111–17, 118–29, 188–97, 203–11, 353–58, 600–07, lists many of the birds that he saw in Texas. See also Audubon, *Birds of America* (1840–1844) 6:139–47, 7:97, 119; Buchanan, *Life and Adventures of Audubon*, 339; and Holley, *Texas*, 100; and JJA to Messrs. Ward & Bell, June 13, 1837, John James Audubon Collection, Department of Rare Books and Special Collections, Princeton University Library, Princeton, NJ. See also *Telegraph and Texas Register* (Houston), May 2, 1837, p. 2, col. 2.

32 Robert Buchanan, ed., *The Life and Adventures of John James Audubon, the Naturalist*, 329–43, which contains extensive passages from Audubon's Texas journal. Samuel Wood Geiser, "Naturalist of the Frontier: Audubon in Texas," *Southwest Review* 26 (Autumn 1930): 109–35, used Buchanan's work, plus passages from Audubon, *Ornithological Biography; or An Account of the Habits of the Birds of the United States of America*, and *The Birds of America, from Drawings Made in the United States and Their Territories*, to reconstruct Audubon's Texas journals, which, along with John H. Jenkins, *Audubon and Texas*, summarizes Audubon's experience in Texas. Samuel Wood Geiser's essay is included in his *Naturalists on the Frontier*, 2nd ed. (Dallas: Southern Methodist University Press, 1948).

33 *Journals of the Senate of the Republic of Texas, First Congress, Second Session* (Houston, 1838), 20, 21, 23, and file #646, 1st Congress, 2nd Session, May 27, 1837 (Republic Inventory #13765) entitled "Preamble and Resolution granting letters of citizenship to John James Audubon." See also John H. Jenkins, *Audubon & Texas* (Austin: The Pemberton Press, 1965), 5–6.

34 Pinckney, *Painting in Texas*, 15–23, quote on 17. Holley wrote *Texas. Observations, Historical, Geographical and Descriptive, in a Series of Letters, Written During a Visit to Austin's Colony, with a View to a Permanent Settlement in That Country, in the Autumn of 1831* (Baltimore: Armstrong & Plaskitt, 1833), and *Texas* (Lexington, KY: J. Clarke & Co., 1836); her diary has been published as well. See James Perry Bryan, *Mary Austin Holley: The Texas Diary, 1835–1838* (Austin: University of Texas Press, [1965]), with reproductions of her sketchy drawings, including the Texas capitol in Houston and James F. Perry's Peach Point house. See the *Telegraph and Texas Register*, October 18, 1837, p. 2, col. 2, for the Andrews's arrival.

35 *Telegraph and Texas Register*, April 28, 1841, p. 3, col. 2; John and Deborah Powers, *Texas Painters, Sculptors & Graphic Artists: A Biographical Dictionary of Artists in Texas Before 1942* (Austin: Woodmont Books, 2000), 10–11. Doreen Bolger, "Ambrose Andrews and His Masterpiece: *The Children of Nathan Starr*," *American Art Journal* 22, 1 (1990): 5–19.

36 Pinckney, *Painting in Texas*, 15, 27 (quoting *The Morning Star* (Houston), April 29, 1841). See also the *Telegraph and Texas Register* (Houston), May 9, 1837, p. 2, col. 1, June 3, 1837, p. 4, col. 1, October 18, 1837, p. 2, col. 2, October 21, 1837, p. 2, col. 2, and April 28, 1841, p. 3, col. 2.

37 *Telegraph and Texas Register* (Houston), May 2 and 16, 1836.

38 Hardin, *Texian Macabre*, 95–97.

39 Cox and Dresel quoted in Hardin, *Texian Macabre*, 99–100; Gustav Dresel, *Houston Journal: Adventures in North America and Texas, 1837–1841*, trans. Max Freund (Austin: University of Texas Press, 1954), 32–33.

40 Rena Maverick Green, ed., *Memoirs of Mary A. Maverick, Arranged by Mary A. Maverick and Her Son Geo. Madison Maverick* (San Antonio: Alamo Printing Co., 1921), 27.

41 Jesús F. de la Teja, "Discovering the Tejano Community in 'Early' Texas," *Journal of the Early Republic* 18 (Spring 1998): 73–98, quote on p. 88; Edward Stiff, *The Texan Emigrant: Being a Narration of the Adventures of the Author in Texas…* (1840; reprint, Waco, 1968), 29; W. Eugene Hollon (ed.), *William Bollaert's Texas*, 219. For more on Bissett, see Powers, *Texas Painters, Sculptors & Graphic Artists*, 42. Francis J. Moore, Jr., *Map and Description of Texas* (New York and Philadelphia: Tanner & Disturnell and H. Tanner, Junr., 1840).

42 For information on McLaughlin, see Powers, *Texas Painters, Sculptors & Graphic Artists*, 328. Thomas Jefferson Green, *Journal of the Texian Expedition Against Mier: Subsequent Imprisonment of the Author; His Sufferings, and the Final Escape from the Castle of Perote* (New York: Harper Brothers, Publishers, 1845).

43 Maverick, *Memoirs of Mary A. Maverick*, 89.

44 Linda S. Ferber, *Hudson River School: Nature and the American Vision* (New York: Skira Rizzoli, 2009).

45 T. J. Ardell, Theodore Lehmann, and Thomas Flintoff in Houston, J. J. Tucker in San Luis, George Allen in Huntsville, and J. E. Churchill at Washington-on-the-Brazos. See *Telegraph and Texas Register*, February 13, 1839, p. 3, col. 5; *San Luis Advocate*, December 10, 1840, p. 3, col. 4; *The Morning Star* (Houston), January 3, 1840, p. 4, col. 2; and Pinckney, *Painting in Texas*, 23–27, 56.

46 Austin to James F. Perry, Monterey [*sic*], January 14, and Mexico, May 10, 1834, in Barker, ed., *Austin Papers*, 2: 1034, 1054. See also Gregg Cantrell, "Stephen F. Austin: Portrait by C. R. Parker," http://fineart.ha.com/common/images/SFA.pdf, accessed January 14, 2014.

47 Haley, *Sam Houston*, 199.

48 William Ransom Hogan, *The Texas Republic: A Social & Economic History* (Austin: Texas State Historical Association reprint, [2006]), 180. The five largest cities in the state in 1850 were Galveston (3,469), San Antonio (3,252), Houston (1,863), New Braunfels (1,237), and Marshall (767). See *Seventh Census of the United States: 1850* (Washington: Robert Armstrong, Public Printer, 1853), 504.

49 See Ron Tyler, *Views of Texas, 1852–1856: Watercolors by Sarah Ann Lillie Hardinge* (Fort Worth: Amon Carter Museum, 1988).

50 An itinerant daguerreotypist named Mrs. Davis set up her apparatus in the Houston House in December 1843, and advertised her services to the public. See David Haynes, *Catching Shadows: A Directory of 19th-Century Texas Photographers* (Austin: Texas State Historical Association, 1993), vii.

51 Pinckney, *Painting in Texas*, discusses each of these artists. In addition, monographs have appeared on Iwonski and Gentilz. See James Patrick McGuire, *Iwonski in Texas: Painter and Citizen* (San Antonio: San Antonio Museum Association in cooperation with the University of Texas at San Antonio Institute of Texan Cultures, 1976) and Dorothy Steinbomer Kendall, *Gentilz: Artist of the Old Southwest: Drawings and Paintings by Theodore Gentilz*, with research by Carmen Perry (Austin: University of Texas Press, 1974).

52 *Neu-Braunfelser Zeitung*, October 14, 1859, quoted in James Patrick McGuire, *Hermann Lungkwitz: Romantic Landscapist on the Texas Frontier* (Austin: University of Texas Press for the University of Texas Institute of Texan Cultures at San Antonio, 1983), 20. See also page 183 for a description of the lithograph.

53 William H. Goetzmann and Becky Duval Reese, *Texas Images and Visions* (Austin: Archer M. Huntington Art Gallery, College of Fine Arts, The University of Texas at Austin, 1983), 22, 25.

54 William W. Newcomb, Jr., *German Artist on the Texas Frontier: Friedrich Richard Petri* (Austin: University of Texas Press, 1978).

55 Melinda Rankin, *Texas in 1850* (Boston: Damrell & Moore, 1850), 190.

Settlers, Artisans, and Immigrants: Evolution and Cultural Continuity in the Building of South Texas

Mario L. Sánchez

When it comes to the history of the South Texas built environment, I have literally experienced more in the field than in the archives. Often overlooked by historians, architects, and other associated disciplines, this history is a puzzle in need of thoughtful assembly to broaden perspectives on this facet of borderlands heritage.[1] My field experiences began on a clear November day in 1988 when I entered South Texas for the first time as an architect for the Texas Historical Commission (fig. 1). I had not studied the region in architecture school, so as I traveled, I felt I was encountering an area untouched by time, where a mix of building cultures, with an always-obvious "Hispanicity," had left behind a remarkable catalog of landmarks extending over two centuries.

Local residents enlivened that initial visit and the many others that followed. It was heartwarming to hear two sisters in San Ygnacio speak of the town's nineteenth-century founder as "Papa Jesusito," as if he were still present among them (fig. 2). Across the river, in the city of Old Guerrero, tragically inundated by Falcon Reservoir in 1953, I was initially perplexed—but later perfectly understood—why a former inhabitant visited the residence he had been forced to abandon. Now in ruins, it had become his spiritual home (fig. 3).

Fig. 1. The Rio Grande near San Ygnacio, Texas.

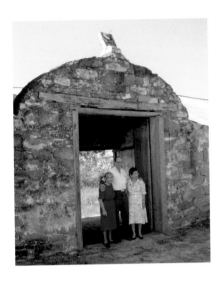

Fig. 2. Treviño-Uribe Family descendants (María Herrera, Rodolfo Sánchez, Margarita Uribe) in 1991 at the gate of the Treviño-Uribe Rancho (Jesús Treviño Fort) built c. 1830–71, San Ygnacio, Texas.

After that initial trip, I started to read about the region and realized that, to understand South Texas within its proper historical context, it has to be studied in relationship to its home base, or cradle, in northern Mexico. In this view, I am not alone. In 1937, historian Florence Johnson Scott wrote in her book, *Historical Heritage of the Lower Rio Grande*, about the ancestral ties linking both sides of the river. In 1930, famed folklorist Jovita González noted, "For nearly two-hundred years the Texas-Mexicans . . . in the border counties . . . looked southward for all the necessities and pleasures of life."[2] In the 1960s, cultural geographer D. W. Meinig observed that once Anglo-Americans came southward in large numbers in the 1920s, they "came in upon the most complete and undisturbed Hispano society in Texas. Deep rooted and stable . . . it was still, essentially, an extension of Mexico."[3] More recently, Scott Cook has argued that to understand the history of brick making on the Rio Grande one must "necessarily" deal with both sides of the border because ". . . the circular flow of people, materials and culture in the brick industry has defied the river boundary as any sort of formidable barrier to movement."[4] Cook's expressed necessity to explore both sides to better understand his topic does not only apply to brick making.

It is this very issue that brings me to the subject of this essay: the cultural continuity between South Texas and Northern Mexico. This heritage continuum weaves an interrelated regional story. Tightly knit by threads of long-standing familial

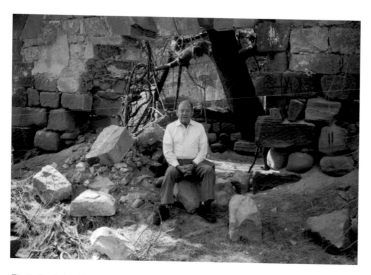

Fig. 3. Dr. Ruben Flores Gutiérrez at his former residence, Guerrero Viejo, Tamaulipas, Mexico.

and cultural bonds, the sites, towns, and cities of South Texas are inextricably linked to Northern Mexico as part of an interdependent historical unit.

Architecture is one of the most visible of those threads, reinforcing the links along and across the Rio Grande and further to its north. Long-established urban patterns and building traditions from Imperial Spain, Vice-Regal New Spain, and the Republic of Mexico evidenced in South Texas were enlivened in the nineteenth century with new influences resulting from trade, transportation, and immigration. Despite this blending of building cultures, inherently Hispanic spatial conventions, building forms, and construction techniques are hallmarks of the distinctive architectural character of South Texas. For Daniel Arreola, South Texas is a "unique Mexican-American cultural province."[5] For me, it is "a land between two nations."[6] Whichever you prefer, both descriptions capture the essence of the region as a place set apart from others with a culture of its own. This essay illustrates how the cultural ties linking South Texas and Northern Mexico continued to be reflected in its architecture, even into the dawn of the twentieth century, indicating that the United States/Mexico cultural border is further north than its political border at the Rio Grande.

Traveling in the early 1850s, Teresa Vielé, the visually astute wife of a U.S. military officer, described the Mexican community of Camargo on the Rio Grande: "the whole place is as un-American in its appearance . . . [in] regards [to] architecture . . . as would be possible to imagine."[7] But she could have been writing about Rio

Fig. 4. San Ygnacio, Texas, photograph, 1919, The Dolph Briscoe Center for American History, The University of Texas at Austin.

Grande City, Camargo's next-door neighbor in the U.S., which was described in 1893 as having "some very substantial buildings, many of them being in the Mexican style."[8] In 1919, architecture critic I. T. Frary wrote "the little towns and villages along the Mexican border . . . make it difficult to realize . . . one is actually within the confines of his own land."[9] Un-American in appearance, but within the United States (fig. 4). Or, using Ima Hogg's words to describe Texas, but applying them to South Texas, "remote or . . . alien to the rest of our nation."[10] In 1988, nearing the end of the twentieth century, I was still able to perceive South Texas in the same manner—un-American, remote, or alien—as others had over a century ago.

Colonizing the Riverlands and the Uplands: Entering into a New Frontier

The genesis of those long-lasting South Texas legacies lies in the eighteenth century. The Spanish crown, slow to react to the La Salle expedition of 1685, responded in 1739 with a royal edict to colonize what was to be the last frontier of the Spanish empire in North America: the Province of Nuevo Santander. Initially surveyed in 1747 by Lieutenant General José de Escandón, the new frontier province was to extend from Tampico to just north of the Nueces River (fig. 5).

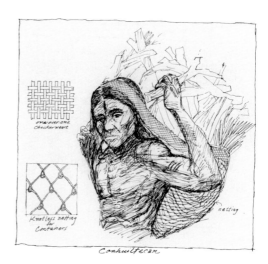

Fig. 5. *José de Escandón,* **Captain General, Province of Nuevo Santander,** *The Dolph Briscoe Center for American History, The University of Texas at Austin.*

Fig. 6. *Native American,* **Coahuiltecan Tribes,** *South Texas, illustration by Robert Jackson, A.I.A., courtesy of the Texas Historical Commission.*

The South Texas portion of the province was defined by the Gulf of Mexico to the east and the Rio Grande to its south, with the Nueces River serving as the natural boundary between Nuevo Santander and the already established Texas to its north. Topographically, South Texas encompassed the lush Rio Grande delta, the Gulf Coast prairies, and the brushy uplands north beyond the great river. Climate-wise, it was hot and arid, with little dependable agricultural land, except for the flood-prone delta. Economically, the land was ideal, but only suitable for the grazing of horses, sheep, and cattle. Travelers in the first half of the nineteenth century described the area of South Texas toward the Rio Grande as a place with a "general aspect of melancholy," where "a death-like silence prevails,"[11] "the forests disappeared at each step,"[12] and the heat rendered it a "veritable furnace."[13]

Nuevo Santander was also intended to serve as a buffer zone between northern New Spain and the nomadic Native American tribes that roamed the region with their accumulated knowledge of trails, low water crossings, and defensible campsites (fig. 6). The Spanish surveyors targeted this pre-historic transportation and habitation

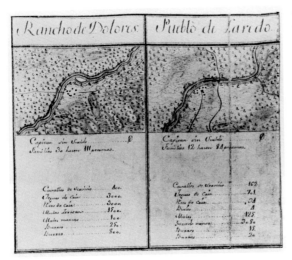

Fig. 7. Pueblo de Laredo and Rancho de Dolores, "Mapa General e Ychnographico de la Nueba Colonia de Santander . . . ," 1758, © The British Library Board.

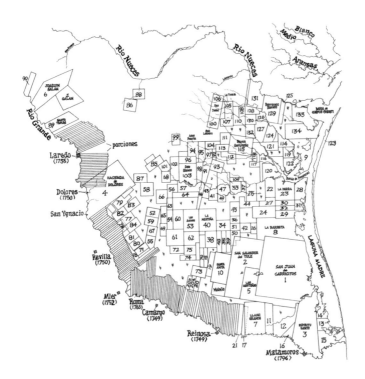

Fig. 8. Ranchos of the Nueces Strip (River Settlements and South Texas Ranches), illustration by Jack Jackson, Texas A & M University Press.

infrastructure for precisely the same practical reasons as the Native Americans, creating a lasting source of conflict between the tribes and the new settlers.

Escandón, the designated captain-general of the new province, led an innovative town planning campaign that was civilian in nature, as opposed to the presidio/mission system initiated by the Spanish in their native land during the Middle Ages at the time of the Reconquest. In 1749, Escandón headed northward with hundreds of members of well-established ranching families from Nuevo León and Coahuila who knew how to turn the rainless plains of South Texas into a successful settlement enterprise. Much like later U.S. homesteaders, the new settlers were lured by the promise of free land and a ten-year tax exemption.

Between 1749 and 1755 five communities and one *hacienda* were founded along the lower Rio Grande as part of the colonization of Nuevo Santander. The Pueblo de Laredo and the Hacienda de Dolores were the two north bank settlements in present-day Texas (fig. 7). Due to fear of flooding, there were no colonization attempts made near the mouth of the Rio Grande.

A royal commission arrived in 1767 for the official allotment of lands. Towns, or *villas*, were configured in a grid pattern with twenty-eight-foot-wide streets and a central public square for church and government buildings, as indicated by the Laws of the Indies decreed in the late sixteenth century to guide Spanish colonization in the Americas. Long, grazing land grants of approximately 5,000 acres, known as *porciones*, were perpendicularly laid out in a row on both sides of the Rio Grande with equal access to water (fig. 8).

Although settling the uplands was also part of Escandón's ambitious initial strategy, which included a port on the gulf, repeated Indian raids delayed the northward movement of settlers into South Texas until the 1770s. Enormous land grants were awarded in the uplands at that time, sometimes encompassing 600,000 acres due to the lack of reliable water sources. It may be from these landed estates that we derive our Texas penchant for gargantuan-sized ranches. By 1795, Nuevo Santander was considered a functioning colonial venture with its 30,000 inhabitants outnumbering those of the older province of Texas.

It was in these ranches and towns that knowledge of architecture and its associated crafts was initially transferred to South Texas from Northern Mexico. Reflective of structures built during the earlier advance of the Mexican frontier and representing "the struggle to take possession of the land,"[14] architecture made permanent the South Texas settlement effort and protected newcomers from Native American raids that would persist into the third quarter of the nineteenth century. Whether ranch

Counter-clockwise from top:
Fig. 9. Jacal, Los Saenz, Texas.

Fig. 10. Tronera, (gunport), Rancho San José
de Corralitos, Zapata County, Texas.

Fig. 11. El Cuarto Viejo (The Old Room),
c. 1830, Treviño-Uribe Rancho (Jesús Treviño
Fort), San Ygnacio, Texas.

hands living on site or itinerant masons erected these buildings is unknown, but these structures certainly exhibit a high level of craftsmanship.

Built of locally available materials, the *casas grandes*, or great houses of the landowners near the Rio Grande, were erected in sandstone quarried from the river cliffs. In turn, they were surrounded by wooden, thatch-roofed *jacales*, which served as dwellings for the ranch hands and their families (fig. 9). Constructed in a manner reminiscent of a *jacal*, an assortment of wooden corrals held livestock.

Two defensive compounds from subdivisions of the 1750 Hacienda de Dolores still stand thirty miles downriver from Laredo. The mud-mortared single-room structure with gunports at Rancho San José de Corralitos is referenced as a *fortaleza*, or fortress, in a recorded legal hearing from 1786 (fig. 10). Topped by a layer of limecrete, or *chipichil*, the roof was rendered fireproof against flaming arrows hurled during attacks. The eighteen-foot-high fortaleza may be significant as the oldest standing secular building in the state of Texas, according to preservation architect Sharon Fleming and archaeologist Timothy Perttula.[15] It was painstakingly rehabilitated in 2006 by building conservator Frank Briscoe and the Moses family, both from Houston.

In another subdivision of Dolores, Jesús Treviño purchased 171,000 acres in 1828 to establish Rancho San Ygnacio. Periodically crossing the river from his hometown of Guerrero to tend his unfenced herds, Treviño built a one-room defensive compound in 1830 (fig. 11). Accessed by a single doorway built of mesquite and swinging on leather-lined pivots, the "fort," as it is called today, would serve as the nucleus for the urban transformation of San Ygnacio later in the century.

Similar to architecture, infrastructure for water collection derived from Spanish and Northern Mexican practices played an essential role in the survival of the thirsty, massive-sized ranches of the uplands. In northern Hidalgo County, Guadalupe El Torero was built of caliche, the lime-based earthen deposit available in the upland plains. Its main house dates prior to 1848, but its *noria de la comunidad*, or community well, dates to the 1790s (figs. 12–13). Water was transferred from a thirty-six-foot-deep well lined with caliche blocks to an adjacent stone tank by means of a leather bucket, after which it was distributed to the livestock in a trough. The McAllen family of South Texas has accurately restored the main house, the well, and a later post-Civil War dwelling of limestone rubble construction.

Highest in rank among the settlements was Laredo, founded in 1755. It was the only colonial foothold in South Texas to attain the status of *villa* and to be formally laid out in 1767 in the traditional urban grid with central plaza. The narrowly

configured plan included a twelve-block area focused around San Agustín Church located in the plaza, and surrounded by the dwellings of the town's founding families. The unimpressed naturalist Jean-Louis Berlandier described these as "nothing but thatch-covered huts called *jacales*"[16] during his visit in 1828.

By the time of Texas independence in 1836, there were more than 350 ranches with three million head of cattle located in over 200 Spanish and Mexican-era land grants extending from the Nueces River to the Rio Grande. While political control over the area was tenuous at this time, the legacies deeded by this collection of settlements to Texas, and eventually to the U.S., were secured for posterity. Socially, the Catholic religion and the Spanish language bound the extended families of the region. Legally, the state of Texas recognized the historic land grants awarded to the descendants of the original colonial settlers. Economically, ranching remained a mainstay enhanced by the American cowboy's adaptation of the Mexican ranching culture, its nomenclature, and techniques. And, architecturally, the use of common building forms, construction methods, and urban patterns expressed the ancestral bonds shared by South Texas and Northern Mexico.

Newcomers to the Riverlands: Urbanizing the North Bank Ranchlands

In the early nineteenth century, during the period when Jesús Treviño was securing his ranching foothold, events on the Rio Grande delta nearly two hundred miles away were having far-reaching social, economic, and cultural impacts on the region due to the swell in trade and immigration first experienced in the city of Matamoros (fig. 14). Originally settled in the 1780s by descendants of the Escandón towns, Matamoros's advantageous position near the Gulf of Mexico enabled it to become a center of international trade in the 1820s at the dawn of Mexican independence. Its location as the closest seaport to the mines of Northern Mexico ensured that their lead, copper, and silver were transported by mule and oxcart trains for export through Matamoros in exchange for imported manufactured goods to be consumed in the Mexican interior.

This lucrative trade created a lively, cosmopolitan city connected to New Orleans, its chief trading partner, as well as Havana, New York, and Europe. Along with a surge in foreign merchants, master builders and skilled craftsmen—especially from New Orleans—arrived in Matamoros to fill the demand for new infrastructure, thereby transferring their technical and stylistic knowledge to the delta region. So close were the city's ties to the Crescent City that it was members of the New Orleanian Passement family who designed Our Lady of Refuge Church in Matamoros's central plaza.

Fig. 12. Main House, built prior to 1848, Rancho Guadalupe El Torero, Hidalgo County, Texas.

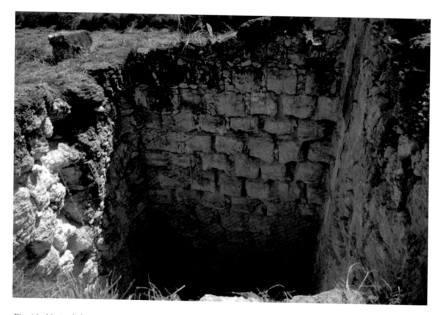

Fig. 13. Noria de la Comunidad (Community Well), built c. 1790, Rancho Guadalupe El Torero, Hidalgo County, Texas.

Fig. 14. *Plaza Hidalgo, c. 1915, Matamoros, Tamaulipas, Mexico, The Dolph Briscoe Center for American History, The University of Texas at Austin.*

Fig. 15. *José Néstor Sáenz Store, 1884, Roma, Texas.*

In that transfer of know-how, brickmaking stands as the signature contribution to the architectural development of the lower Rio Grande. Brick was employed in all components of construction, including rooftops where lightweight units were layered over wooden beams, a building technique also seen in the Caribbean and Mexico. Introduced throughout the region by itinerant artisans who have been mostly unrecorded by history, brick manufactured under the supervision of a *maestro*, or master brick maker, became the building material of choice in the lower Rio Grande by the third quarter of the nineteenth century.

Situated in a delta region devoid of native stone, Matamoros was built in brick over a Spanish colonial town plan. Responding to the typical conventions of enclosed Spanish-Mexican urban space, the buildings of Matamoros literally delineate the narrow streets with their continuous front façades, as they open to a central plaza focused on church and government buildings. This rigid layout contrasts with the less formal Anglo-American tradition, described by a Mexican visitor to San Felipe de Austin in 1828 as having "houses not arranged systematically . . . to form streets," but rather set in an "irregular and desultory manner."[17]

It was within this traditional spatial framework of inward-focused, courtyard plan structures that a distinctive regional architectural style was created in Matamoros. The style offered an elegant interplay of classical motifs compatible with those of New Orleans and the Caribbean, as well as the upriver Escandón communities, which also embellished their building corners, doorways, and window openings. The result of this blend of forms and stylistic influences is the Border Brick style (fig. 15). Composed around a base, pilasters, and entablature in a variety of details and configurations, the Border Brick style provided a new dimension to the regional architecture, bonding it to the building culture of the founding settlements, and giving it, in the words of Stephen Fox, a "transnational identity."[18]

Added to these social, economic, and architectural developments in the early decades of the century, and of even further consequence to South Texas, was the official demarcation of the Rio Grande as the U.S./Mexico political boundary at the end of the Mexican War in 1848. Socially, the region was opened to Anglo-American settlement and its ensuing cultural influences. Economically, the new American era energized ranching and monopolized trade with Northern Mexico, turning the Rio Grande into a navigable, highly profitable commercial corridor plied by steamboats.

With Matamoros as their blueprint, cadres of U.S. entrepreneurs, merchants, and soldiers of fortune participated in the platting of new towns on the north bank directly across the river from the Escandón towns. Unlike those established towns that followed the Laws of the Indies, the ones in the north bank responded to American urban traditions with a wider street grid lacking public or ceremonial spaces.

Steamboat navigation, already experienced during the Mexican War, connected the new and old communities over a one hundred-mile stretch of river extending from the gulf to the new town of Roma, the headwater of navigation. Acting as the middlemen for the Mexican minerals trade and import of manufactured goods, the north bank towns quickly generated vast wealth for the astute individuals who dominated the multiple commercial enterprises simultaneously taking place at the dawn of the American era. Among these legendary figures were steamboat captains Richard King and Mifflin Kenedy, later of Texas ranching lore.

With steamboats acting as harbingers of change, much in the same manner as railroads would later in the century, the social, commercial, and cultural exchange they facilitated between the old and the new towns of the lower Rio Grande after 1848 also influenced architecture. Steadily, the brick industry traveled upriver in tandem with the Border Brick style, supplanting native stone construction.

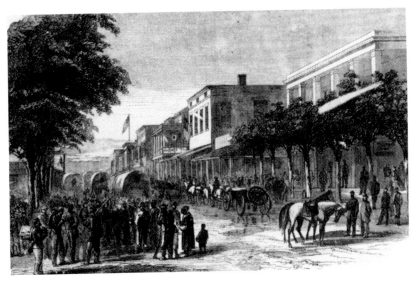

Fig. 16. Elizabeth Street, Brownsville, Texas, 1863, University of Texas at San Antonio Libraries Special Collections.

Brownsville, founded in 1848 across the Rio Grande from Matamoros, was the point of departure for the new brick industry and its accompanying style (fig. 16). Established by Connecticut-born Matamoros entrepreneur Charles Stillman, Brownsville was intended to serve as the new U.S.-dominated commercial gateway to Northern Mexico. Following a similar development pattern to its sister city, Brownsville's rapid prosperity surpassed that of Matamoros as it exerted control over the Mexican minerals trade and steamboat lines. The observant Teresa Vielé recorded that immigrants, builders, and skilled laborers in Brownsville erected buildings that "bore the mark of inevitable progress or go-aheaditiveness, otherwise called 'manifest destiny.'"[19] Given his intense financial acumen, it is not surprising that Stillman maneuvered manifest destiny in his favor. By the time he retired to New York City in 1866, Stillman's borderlands fortune made him one of the richest men in the United States.

Lacking public spaces and a grand avenue, Brownsville's 308-block town plan was a testament to the utilitarian expectations of its founders. Responding to U.S. urban traditions by way of New Orleans, the architecture of the new gateway city, unlike that of the Escandón towns, exhibited building setbacks, detached dwellings, and landscaped neighborhoods. These included wood-framed houses, such as the Martin Hanson House (1868) with arcaded porch in the city's fashionable West

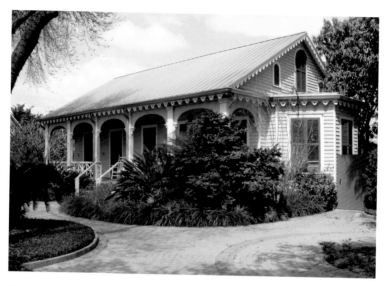

Fig. 17. Martin Hanson House, 1868, Brownsville, Texas.

End (fig. 17). Constructed by Martin Hanson, a Norwegian-born builder who worked in New Orleans, immigrated to Matamoros, and then crossed to Brownsville— a not unusual move at the time—the dwelling exhibits distinctly Anglo-American building traits.

But Brownsville's border location and its large Hispanic population, both immigrant and local, created a blended built environment. A Spanish/Mexican urbanscape can be experienced in the presence of large enclosed commercial/residential compounds, giving the city that uncommon "land between two nations" feel of the borderlands. Illustrating the point, the street-lined Juan Fernández y Hermano Complex (1884–1906) alludes to Matamoros and the Caribbean, while the Manuel Alonso Building (c. 1890) displays a varied rendition of the Border Brick style with its New Orleans-influenced double galleries.

Ninety miles upriver, the founding of Rio Grande City in 1848 validated Vielé's view that "Americans on the Rio Grande may be considered as the most daring, adventurous set of men in the world . . . [with] a reckless spirit of adventure."[20] Henry Clay Davis established it as a river port after he cleverly married the Mexican heiress who inherited the ranchlands situated directly across the Escandón town of Camargo that would become Rio Grande City.

Fig. 18. Silverio de la Peña Post Office and Drugstore, 1886, Rio Grande City, Texas.

Fig. 19. Sandstone Cliffs at the Rio Grande, Roma, Texas, 1857, The Dolph Briscoe Center for American History, The University of Texas at Austin.

Cosmopolitan in atmosphere, especially after the arrival of additional immigrants following the 1866 defeat of Emperor Maximilian in Northern Mexico, Rio Grande City's one hundred-block plat, in comparison to Brownsville, is more defined by walled, gated courtyard compounds. Built at the height of the town's steamboat-generated prosperity in the last two decades of the nineteenth century, one of these bricked compounds stands apart in the city and in the region. Designed by itinerant, German-born master builder and mason Heinrich "Enrique" Portscheller, the Silverio de la Peña Post Office and Drugstore (1886) reveals the increased complexity of the Border Brick style as it extended upriver (fig. 18). The side-yard complex displays a skillful combination of classical elements in myriad shapes, including fluted columns assembled from rounded brick units, and, typical of the region, the initials of its owner and construction date embossed in its cornice.

Alongside these courtyard Mexican building types, a series of detached, hip-roofed commercial and residential properties in brick also give the urbanscape of Rio Grande City a mixed spatial appearance suggesting its border condition. But even these detached buildings did not escape the Hispanized regional peculiarities in which the Domingo and Donna Garza Residence (1894–1914), an Anglo-American inspired hip-roofed dwelling, is gated and walled along its perimeter.

Ten miles upriver from Rio Grande City, sitting atop 200-foot-high sandstone cliffs, and much like a "hamlet on the Rhine,"[21] as it was described in the late nineteenth century, the town of Roma was founded in 1848 by Stillman to compete with Davis's downriver port (fig. 19). Different from the American-dominated founding of Rio Grande City and Brownsville, the native families of the south bank city of Mier, who owned the ranchlands where Roma was to be platted, were active participants with Stillman in the urban enterprise. As a result, Mexican architectural precedents in native sandstone were built during the early years of Roma, contributing to the city's more Hispanized appearance. The Filomeno Góngora House (c. 1850), probably assembled by itinerant masons from Mier, showcases exterior plaster remnants in a cobalt blue color typical of Northern Mexico.

Roma's picturesque appearance is enhanced by streetscapes framed by walled commercial/residential properties in brick punctured by gateways. Adapting an American plat to Hispanic urban traditions, Roma's short, two-block long central avenue conveys the appearance of a plaza in the manner of a traditional Escandón town. A church dominates one end, while walled compounds enclose its sides.

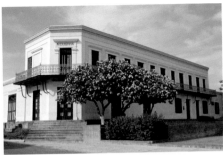

Left: Fig. 20. Decorative interior plaster detail, José Camilo Sáenz Salinas House and Store, 1884, Roma, Texas.

Above: Fig. 21. Manuel Guerra Store and Residence, 1884, Roma, Texas.

Central to the manufacture of brick in Roma was the enterprise of Portscheller, who arrived there in 1881, and his partners Prudencio Pérez and Ruperto Margo. Having been exposed to the established brick culture of the riverlands, Portscheller enhanced and made more complex the Border Brick style, incorporating finely crafted details into his buildings with his skills as a master mason. Although he practiced as far south as Monterrey, his built legacy displaying high integrity and sophistication is mainly centered in Roma.

Prominent among this legacy is the José Camilo Sáenz Salinas House and Store (1884) on the plaza with its rare display of decorative interior plaster typical to Northern Mexico (fig. 20). Also, the José Néstor Sáenz Store (1884), with its intricate brick architraves framing its doorways, is a delicately crafted example of the Border Brick style.

The end of the nineteenth century initiated a period of isolation for the lower Rio Grande region due to the lack of railroads and the gradual ebbing of the steamboat trade. Although isolation would end for Brownsville in 1904 and for Rio Grande City in 1925 with the arrival of the railroad, it would never end for Roma, as the

Fig. 22. Floor Plan, Treviño-Uribe Rancho (Jesús Treviño Fort), c. 1830–71, San Ygnacio, Texas.

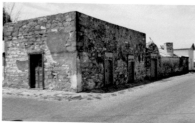

Fig. 23. Treviño-Uribe Rancho (Jesús Treviño Fort), built c. 1830–71, San Ygnacio, Texas.

railroad perennially eluded the picturesque hamlet on the river cliffs. With its historic fabric literally frozen in time, Roma stands today as a remarkable catalog of the built environment of the lower Rio Grande (fig. 21).

Sixty miles upriver, as if receding further in time and increasing the Mexicanization of the urbanscape, San Ygnacio's social, economic, and cultural isolation is eminently manifested in its architecture. As descendants of Jesús Treviño crossed the Rio Grande in 1848 to preserve ownership of their now American homestead, the family undertook an ambitious building campaign. The original one-room ranch fortification grew into a block-long defensive compound displaying a rounded gateway with sundial and hand-hewn dated beams—an interior feature distinctive to the region (fig. 22). Amazing for its nearly intact survival to this day, the "fort" is currently under restoration by San Ygnacio's River Pierce Foundation (fig. 23).

Over the next decade, as other members of the extended family clustered homes around the compound, town elders spearheaded an urbanization effort begun in 1874 which involved a gridded street system that responded not to U.S. traditions but to the Laws of the Indies with a plaza dominated by a church.

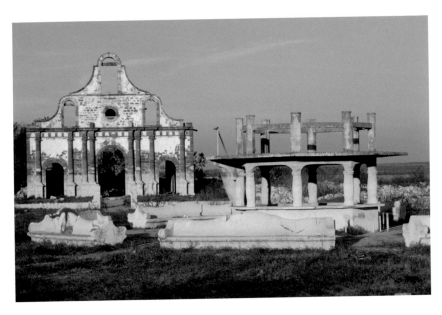

Fig. 24. Plaza Vicente Guerrero, Guerrero Viejo, Tamaulipas, Mexico.

Defined by flat-roofed sandstone structures with decorative plaster, the town's new spatial configuration and stylistic influences recalled those of Treviño's ancestral homestead across the river in Guerrero, which was probably a source for the itinerant masons who built San Ygnacio (fig. 24).

Without steamboats, railroads, or a brick industry, the citizens of San Ygnacio continued to build following eighteenth- and nineteenth-century customs into the twentieth century. Hints of U.S. building trends appeared after 1895 with an occasional shallow setback or porch addition, as demonstrated in the Zaragoza-Domínguez Complex (1899–1900) (fig. 25). Admirably restored by the River Pierce Foundation, these turn-of-the-century buildings were still faced in sandstone and bordered by a traditional *banqueta*, or sidewalk of large river stones. In fact, it would not be until the 1920s that the 198 closely related citizens of San Ygnacio accepted their first truly American building in the form of a wooden bungalow. The acceptance may have been born out of necessity, given the scattering of the south bank Mexican population, including its itinerant masons, following the Revolution of 1910.

At the northern end of the Lower Rio Grande, Laredo ended its isolation and surpassed its native sandstone architecture with the arrival of the railroad that

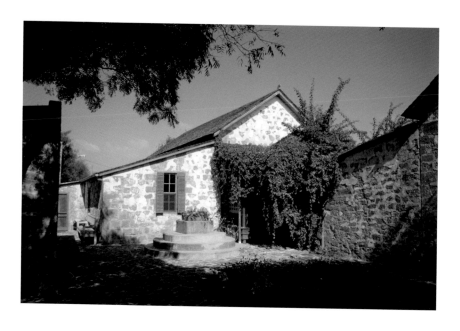

Fig. 25. Zaragoza-Domínguez House and Store, built 1899–1900, San Ygnacio, Texas.

Fig. 26. Zaguán (entryway), José Reyes Ortíz House, built c. 1830–72, Laredo, Texas.

linked it to Corpus Christi in 1881 and to Mexico City in 1890. Laredo's urban grid expanded with neighborhoods showcasing detached houses in brick in American mainstream styles with landscaped yards and porches. But in the city's Spanish colonial core, the courtyard houses of San Agustín continued to be inhabited by the heirs of the city's founding families, even well into the twentieth century (fig. 26). Adherence to social and cultural identification through continued ownership of ancestral family properties may be described as emotional participation in place, as indicated by Daniel Arreola.[22] This intangible trait is customarily observed in Hispanic settlements of South Texas where a *porción* can still be owned in common by as many as 2,000 heirs, or where a building can be legally precluded from sale outside the family for several generations after its construction.

Newcomers to the Uplands: Urbanizing the Ranchlands of the South Texas Plains

Much like steamboats on the Rio Grande, the railroad brought its associated trade, immigration and urban development to the upland ranches located near the 162-mile-long Corpus Christi to Laredo segment of the Texas Mexican Railway. Turning ranching outposts into shipping centers, the company sought lands from established families to plat standard-plan towns that drew their populations from nearby ranches. As a result, Hispanic urban planning and architectural practices were part of these new towns of American genesis tied to a modern transportation network.

Sixty miles west of Corpus Christi, San Diego was founded in 1852 adjacent to land grants dating to 1812 awarded to families from the Escandón town of Mier. Platted in 1876, its plan included a central plaza with a city hall and church planned as a separate spatial entity from the nearby Anglo-American county courthouse square (fig. 27). Denoting civic and religious authority in Hispanic terms in accordance with the Laws of the Indies, the plaza is indicative of San Diego's five hundred Mexican inhabitants compared to fifty Anglo-Americans in an 1875 census, and signals the presence of Hispanic ranchers at the town's founding.

Midway along the rail line, Benavides also included a plaza at the time of its platting in 1880. Its off-center location away from the commercial district did not deter the town's Catholic church, post office, and businesses from locating in the landscaped square (fig. 28). Adherence to Hispanic building traditions on and near the plaza is revealed in the Francisco Salinas Store (1910) in caliche block, and in the two-story Olivera Dry Goods Store (1900) built of rubble limestone with decorative plaster patterns recalling the Rio Grande borderlands.

Fig. 27. Partial Town Plan with Plaza, platted 1876, San Diego, Texas.

Fig. 28. The Plaza, platted 1880, with St. Rose of Lima Catholic Church (1940), Benavides, Texas.

Further west and sixty miles from Laredo, Hebbronville offers a particular mixture of architectural and cultural traditions that literally tie an American-founded town from 1883 to its Mexican heritage. At one corner of its off-center plaza, the current Our Lady of Guadalupe Catholic Church, more attuned to church design in Mexico than the United States, replaced a nineteenth-century structure in 1962. In the next block, a dwelling suggests the continued cultural engagement between South Texas and Northern Mexico well into the twentieth century. The caliche block Bonifacio Garza Residence (1893) housed for several decades a teacher from the Colegio Altamirano, a Hebbronville-based school founded in 1897. Lasting until 1958, the *colegio* was one of several in the rural uplands instituted to inculcate Mexican customs in the children of Hispanic families.

Our eighteenth- and nineteenth-century architectural tour of South Texas appropriately ends in 1932 in the ranching settlement of La Rosita in Duval County. Located on a historic caliche dirt road linking Corpus Christi and Laredo prior to the railroad, La Rosita was settled in 1830 by the Valerio family from Mier. Serving as a trading post for area ranchers and then as an automobile stop in the

Fig. 29. Valerio Family Store, 1932, La Rosita, Duval County, Texas.

1920s, La Rosita's heyday came to a close in 1934 with the relocation of the road to the north as the newly paved State Highway 44. But its heyday did not end before the Valerio family built its new home in 1926 and a new store in 1932 (fig. 29). With their front façades embossed with their construction dates and owner's name, and with their walls assembled from limestone rubble, these twentieth-century structures are tied to nineteenth-century borderlands building traditions, despite the availability of brick and wood in nearby communities. Located today on that still dirt-covered road, La Rosita indicates that their further distance to the north did not diminish the cultural ties of these upland ranches to their ancestral homeland south of the Rio Grande.

Conclusion: An Enduring Sense of Identity

As we survey the built environment of South Texas, we better understand how buildings fit into history as reflections of trade, transportation, immigration, and military conflict—all of which are consequential to the architectural development of a region. For South Texas, the openness instigated by those dynamic historical

Fig. 30. *San Agustín Plaza, platted 1767, Laredo, Texas.*

Fig. 31. *Plaza Juárez, platted 1767, Mier, Tamaulipas, Mexico.*

forces created an inventive blend of building forms, styles, and urban patterns in varied modes that further enhanced the architectural heritage of the region. Central to this blend are the time-tested Hispanic overtones of the built environment clearly discerned even into the early decades of the twentieth century.

This discernible continuity of Hispanic urban and building practices is part of a wider set of firmly ingrained social, economic, and cultural traditions—emerging in the eighteenth, cemented in the nineteenth, and persisting into the twenty-first century—that are integral to the unique sense of regional identity manifested in South Texas and its borderlands. Drawing strength from a network of interconnected families and communities, this enduring sense of identity is architecturally reinforced through a striking ensemble of sites, buildings, and public spaces. Compelling but fragile, this tangible collection of architectural remnants broadens our notion of U.S. heritage, and, borrowing Ima Hogg's analogy for Bayou Bend, it also "serves as a bridge"[23] that links the shared legacies of two nations in a region not duplicated elsewhere in Texas, Mexico, or the United States (figs. 30–31).

Notes

1 I would be remiss if I did not mention individuals who have explored and further defined the building cultures of South Texas over the last half century, including archeologists Joe Cason and José Zapata; Professors Eugene George, Wayne Bell, Stephen Fox, Scott Cook, and Daniel Arreola; architectural conservator Gregory Free and preservation architect David Hoffman. I especially remember discovering Hoffman's master's thesis on Roma, Texas, on a library shelf and wondering, "Where in Mexico is this place?"

2 Jovita González, "America Invades the Border Towns," *Southwest Review* XV, 4 (Summer 1930): 469.

3 D. W. Meinig, *Imperial Texas, An Interpretive Essay on Cultural Geography* (Austin: University of Texas Press, 1993), 100.

4 Scott Cook, *Mexican Brick Culture in the Building of Texas, 1800s–1980s* (College Station: Texas A & M University Press, 1998), xx.

5 Daniel D. Arreola, *Tejano South Texas: A Mexican American Cultural Province* (Austin: University of Texas Press, 2002), 7.

6 Mario L. Sánchez, "A Land Between Two Nations: Preserving the Cultural Resources of the Lower Rio Grande Region," *Historic Preservation Forum* 7, 1 (January/February 1993): 36.

7 Teresa Griffin Vielé, *Following the Drum: A Glimpse of Frontier Life* (1858; repr., Lincoln: University of Nebraska Press, 1984), 178–79.

8 Lieutenant W. H. Chatfield, *The Twin Cities of the Border, Brownsville, Texas and Matamoros, Mexico and the Country of the Lower Rio Grande*, 1893, quoted in Cook, *Mexican Brick Culture*, 292.

9 I. T. Frary, "Picturesque Towns of the Border Land," *Architectural Record* 45 (April 1919): 382.

10 Ima Hogg, foreword in David Warren, *Bayou Bend: American Furniture, Paintings, and Silver from the Bayou Bend Collection* (Houston: Museum of Fine Arts, Houston 1975), viii.

11 Abbé Domenech, *Missionary Adventures in Texas and Mexico: A Personal Narrative of Six Years' Sojourns in those Regions*, 1858, quoted in Eugene George, *Historic Architecture of Texas: The Falcon Reservoir* (Austin: Texas Historical Commission and Texas Historical Foundation, 1975), 19.

12 Jean Louis Berlandier, *Journey to Mexico During the Years 1826 to 1834*, trans. Sheila M. Ohlendorf et al., 1980, quoted in Arreola, *Tejano South Texas*, 14.

13 Abbé Domenech, *Missionary Adventures in South Texas*, quoted in Stephen Fox, *"La Frontera Chica: Laredo and the Texas-Tamaulipas Border: 2004 City Tour,"* unpublished manuscript, 54.

14 Joe S. Graham, *"The Built Environment in South Texas: The Hispanic Legacy,"* in *Hispanic Texas: A Historical Guide*, eds. Helen Simons and Cathryn A. Hoyt (Austin: University of Texas Press, 1992), 75.

15 Sharon E. Fleming and Timothy K. Perttula, "San José de Corralitos, A Spanish Colonial Ranch in Zapata County, Texas," *Bulletin of the Texas Archeological Society* 70 (1999): 409.

16 Berlandier, *Journey to Mexico*, quoted in Fox, *"La Frontera Chica,"* 20.

17 José María Sánchez, "A Trip to Texas in 1828," quoted in Meinig, *Imperial Texas*, 36.

18 Stephen Fox, "Border Modern: Modern Architecture of the Texas-Mexican Border," Lower Rio Grande Chapter, American Institute of Architects, Building Communities Conference, South Padre Island, September 28, 2013, 5.

19 Vielé, *Following the Drum*, 104.

20 Ibid., 152.

21 Chatfield, *The Twin Cities*, quoted in Fox, "La Frontera Chica," 73.

22 Arreola, *Tejano South Texas*, 203.

23 Hogg, foreword, viii.

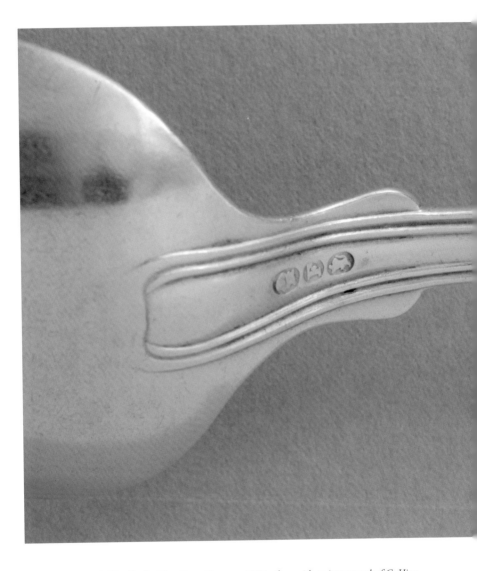

Fig. 1. **Spoon**, retailed by Charles Hine, Bexar County, c. 1870, silver, with an incuse mark of C. Hine and an unknown maker's mark, private collection.

The Search for Early Texas Silversmiths

D. Jack Davis

In the preface of the catalogue of the Bayou Bend Collection published in 1975, collector, philanthropist, and Bayou Bend benefactor Ima Hogg states: "Texas, an empire in itself, geographically and historically, seems to be regarded as remote or alien to the rest of our nation."[1] With regard to the material culture or the decorative arts, especially silver, this has been the case. There has been, though, a general rise of interest in Southern decorative arts during the past several decades, bringing increased attention to the nineteenth-century South and Southwest and specifically to Texas.

The material culture of nineteenth- and early twentieth-century Texas has attracted a growing number of scholars. Georgiana Greer and Harding Black's *The Meyer Family: Master Potters of Texas* [2] was published in 1971. Cecilia Steinfeldt and Donald Stover organized an important exhibition on early Texas furniture and decorative arts at the Witte Museum in San Antonio in 1972 and wrote an accompanying catalog entitled *Early Texas Furniture and Decorative Arts.* [3] Lonn Taylor and David B. Warren

published their classic book, *Texas Furniture: The Cabinetmakers and Their Work, 1840–1880* in 1975.[4] This foundational work was followed with Greer's publication, *American Stonewares: The Art and Craft of Utilitarian Potters,*[5] in 1981; Buie Hardwood's book on nineteenth- and early twentieth-century interior decorative painting, *Decorating Texas,*[6] in 1993; and Michael K. Brown's *The Wilson Potters: An African-American Enterprise in 19th-Century Texas,* in 2002.[7] These significant publications and exhibitions provide a foundation for the expanding field of nineteenth- and early twentieth-century Texas decorative arts.

The establishment of the William J. Hill Texas Artisans and Artists Archive[8] at Bayou Bend represents a major leap forward in advancing scholarship in this area by making information digitally available. Similarly, a great interest in early Texas art (painting, sculpture, and original prints) has emerged in the past thirty-five years, with the assembly of outstanding collections by private collectors, the organization of numerous exhibitions by Texas museums and historical societies, large and small, and the founding, eleven years ago, of the organization CASETA: The Center for the Advancement and Study of Early Texas Art.[9]

Within this broader area of inquiry, the focused study of Southern silver and silversmiths has also led to a growing body of scholarship, but very few of these efforts have concentrated on Texas silver and silversmiths. In general the South, and particularly Texas, was primarily rural during the 1800s, and it lacked the concentration of silver craftsmen found in other parts of the country. Much of the scholarship that does exist on Southern silver primarily focuses on work done in major Southern cities: Annapolis, Atlanta, Baltimore, Charleston, Lexington, Louisville, Mobile, New Orleans, and Savannah.[10] Nevertheless, objects produced by Southern craftsmen who lived outside these major population areas are constantly being uncovered, leading to reconsideration of long-held assumptions about the dearth of silver production in the South. The relative lack of research on Texas silversmiths has hindered both students and collectors of silver from identifying and studying the work associated with Texas in an in-depth manner.

While a large portion of the fine household goods, including silver, used in the nineteenth-century South was imported from the North or from abroad, Warren points out in the 1968 catalog for an exhibition of silver made in the South prior to 1860 that "even the most cursory examination of the publications on Southern silversmiths suggests that there were in fact many craftsmen active in the area" and that "it appears likely that there was probably a great deal more silver made than

many have previously thought."[11] In an article in *The Magazine Antiques*, Warren states that "a great portion of the silver made in the South dates from the nineteenth-century and is still awaiting identification."[12] Since Warren wrote these words more than four decades ago, the then-emergent scholarship on Southern silver has expanded considerably.[13] In the 1971 article, he offered the first published teaser regarding Texas silver, stating that "surprisingly, a few isolated Texas examples (of silver) are also known."[14]

My own journey to learn more about the silversmiths and goldsmiths who worked in nineteenth-century Texas was motivated by: (1) the aforementioned foundational work in the decorative arts and (2) Warren's comment and his speculation that a great portion of the silver made in the South was awaiting identification. Before embarking on this journey, some parameters had to be established to keep the investigation focused. Two questions first had to be answered: (1) Would the search be limited to only those individuals who were identified or identified themselves as silversmiths or goldsmiths, or would jewelers and watchmakers who often produced and/or retailed silver objects as well be included? (2) What time period would be covered? Within this context, it was decided to include only those individuals who were identified or identified themselves as silversmiths or goldsmiths.

The whole pattern of silver production was changing by the second quarter of the nineteenth century with the individual craftsmen being replaced by manufacturers. Silversmiths who crafted silver objects often sold items produced by manufacturers as well. At the same time, many individuals who were not craftsmen retailed objects produced by manufacturers and often advertised as silversmiths. Thus, the actual origin of much nineteenth-century American silver presents a knotty problem because sometimes the manufacturer's mark and the retailer's mark were included on an object (fig. 1), but sometimes only the retailer's mark was placed on the object.[15]

The year 1880 was chosen as the cut-off point of this particular study because by this time industrialization and mass production dominated the production of silver goods for public consumption in the United States, a trend that began in the 1850s. For example, Gorham opened a wholesale showroom in New York in 1859 "since that was the market center to which most silverware retailers came to replenish their stock on annual buying trips," and the firm "continued to sell solely to the wholesale trade until 1873."[16] By 1880 the silver manufacturers were firmly established on the East Coast and were supplying goods to individuals and retailers throughout the country.

With those two questions resolved, the various directions that the journey might take were considered, and it was determined that several paths would be pursued.

The first involved finding the names of individuals who were identified or who identified themselves as silversmiths or goldsmiths, and, once identified, research was conducted to find as much information about these artisans as possible. Several questions were asked, including: Where were they from? Were they itinerant, or were they immigrants? If they were immigrants, where did they live and work in Texas? Did they work as independent craftsmen or did they establish businesses? What biographical information is available or can be assembled for each artisan? Do examples of their work exist, and how are they marked? These questions were pursued simultaneously.

At the beginning of this journey in the early 1980s, an examination of the published literature identified the names of only twelve silversmiths (seven family names) working in Texas prior to 1900. They were Fred Allen;[17] Adolph Bahn;[18] Samuel Bell,[19] and his sons: David Bell,[20] Jessup M. Bell,[21] Powhattan Bell;[22] A. B. Carter;[23] Albert, Charles, and Gustavus Adolphus Iankes;[24] Adolph Lungkwitz;[25] and S. D. Morrill.[26]

However, an examination of the summary data for the United States Population Censuses of 1850,[27] 1860,[28] 1870,[29] and 1880[30] indicated that there were more than 200 individuals who worked as silversmiths or goldsmiths in Texas over this thirty-year span: 27 in 1850,[31] 67 in 1860,[32] 111 in 1870,[33] and 50 in 1880[34] (fig. 2). These numbers and a growing curiosity provided motivation to continue the journey.

In addition to the population censuses, information was also obtained from manufacturing and industry censuses for 1850, 1860, 1870, and 1880. These schedules collected information about manufacturing and businesses with an annual gross product of $500 or more.[35] These censuses were examined to confirm the work of individuals listed on the population censuses, as well as to identify possible additional names that might have been excluded from the population censuses. The 1860 and the 1870 Products of Industry Censuses confirmed several individuals and identified at least one additional individual engaged in the production of gold and silverware.[36]

Accounting for duplicate names, 175 individuals were actually found on the four Population and Products of Industry Census rolls for 1850, 1860, 1870, and 1880, considerably more than the 12 who could be identified in the published literature initially. Because of uncertainties surrounding several of the names on the census rolls, this number should not be viewed as absolute. Along the way, 62 additional individuals were identified as silversmiths from various sources such as the censuses of the early missions, newspaper advertisements, published materials,

Individuals Identified on Census Rolls
1850, 1860, 1870, 1880

Census Year	Summary Data	Actual Number	Duplicates	Final Number
1850	27	29	0	29
1860	67	69	5	64
1870	111	44	8	36
1880	N/A*	50	4	46
TOTAL				175
Other Sources				62
GRAND TOTAL				237

*1880 census did not differentiate between silversmiths, goldsmiths, and jewelers; collectively there were 225 working in Texas in 1880.

Fig. 2. Individuals Identified on Census Rolls: 1850, 1860, 1870, and 1880.

museum collections, and a variety of other sources. Collectively, the names of 237 individuals were identified who are documented in some way as silversmiths in Texas prior to 1880.

While there is no evidence to support that any of the silversmiths were itinerant, only a very small portion of the identified individuals actually worked as silversmiths, jewelers, or watchmakers over an extended period of time. Fifteen individuals were listed on two or more of the census rolls (1850–80) as silversmiths. Three individuals appeared on three consecutive census enumerations. A fourth individual, William Simpson of Nacogdoches County, appeared on the 1850 and 1860 U.S. censuses, as well as the 1840 Mexican Census of Texas.[37] Another 11 were listed as silversmiths on one census, and as jewelers or watchmakers on another (fig. 3). The numbers in these two groups are not as large as hoped, since duplication from census roll to

census roll would indicate a sustained and serious commitment to an established career as a silversmith or goldsmith. Additional historical data, including repeated newspaper advertisements, reveal that there were other silversmiths who worked in Texas for longer durations of time than found on the census rolls. For example, Gustavus Adolphus Iankes appeared on the 1860 population census as a silversmith working in Chappell Hill, Washington County, and as a jeweler working in the same town on the 1870 population census. Historical records indicate that Iankes worked in Texas prior to 1850. Coming to Texas in the mid-1840s, he left for the California gold rush in 1849 and returned to Texas in 1852, not appearing on the 1850 Texas population census.[38] Josiah Bishop, who will be discussed later, is another example.

In the nineteenth century, the United States, and especially Texas, was a land of immigrants, so the countries or regions of origin for these 237 identified silversmiths was naturally of interest. For those individuals named in the census rolls, the place of birth is included in the census data, and this was considered to be the place from which the silversmiths immigrated to Texas unless other data indicated otherwise. For those individuals identified from other sources, determining their places of origin was more difficult. Not surprisingly, the majority of these artisans were not born in Texas, only 23 (10%) were; 110 (46%) emigrated from foreign countries, and 76 (32%) were from other parts of the United States. The origins for 28 (12%) of these silversmiths remain undetermined. Those with foreign roots came primarily from two countries: Mexico (54) and Germany (34). The remainder were from a variety of places, primarily western European countries. Those silversmiths who came to Texas from other parts of the United States came from twenty-one states. The largest number of silversmiths—15—were from Tennessee, followed by 10 from North Carolina. These two states were followed by New York (7), Kentucky (6) Georgia (5), and Arkansas, South Carolina, and Virginia, with 4 each. The remaining fourteen states were represented by 1 or 2 immigrants each (fig. 4).

Fig. 3. Silversmiths/Jewelers/Watchmakers on More than One Census Roll.

Silversmiths/Jewelers/Watchmakers on More than One Census Roll

Silversmith	County	1850 Census	1860 Census	1870 Census	1880 Census
Franco, Juan	Bexar	S	S	S	
Bernal, Francisco	Webb		S	S	S
Walker, Williamson M.	Collin		S	S	S
Simpson, W. P.*	Nacogdoches	S	S		
Ballard, C. A.	Goliad & Atascosa	S	S		
Berrara, Augustin	Bexar	S	S		
Sossaman, Jacob	San Augustine	S	S		
McFail, D. M.	Harrison		S	S	
Sanchez, Juan	Cameron		S	S	
Lasso (?), Garbino (?)	Nueces		S	S	
Lopez, Nicholas	Cameron	S	S		
Voltaire, Alex	Houston		S	S	
Cloyd, W. S.	Collin		S	S	
Cordoba, Joseph	El Paso			S	S
Lopez, Nicholas	Cameron			S	S

Silversmith/Jeweler/Watchmaker

Silversmith	County	1850 Census	1860 Census	1870 Census	1880 Census
Bahn, Adolph	Travis		S	W&C	J
Bell, David	Bexar		S	J	J
Bell, Jessup	Bexar		S	J	J
Oliphant, Wm. O.	Travis		S	WM	WM
Bell, Samuel	Bexar		S	J	
Bishop, Josiah	Travis/Washington/Harris			S	J
Iankes, Gustavas A.	Washington		S	J	
Murphy, Archer M.	Rusk/Smith		S	J	
Shuster, Louis	Harris			S	J
Williams, D. M.	Walker		S	J	
Harris, Thomas B.	Montgomery	S		WM	

* Identified as living in Nacogdoches in the 1840 Mexican Census, although no occupational data were provided.

S = Silversmith J = Jeweler W&C = Watch & Clock Maker / Repairer WM = Watch Maker

Origins of Early Texas Silversmiths
(n = 237)

Non-Immigrant Silversmiths (10%)

Texas	23

Immigrants with Foreign Origins (46%)

Austria	1
Canada	3
Czechoslovakia (Bohemia)	1
England	3
Finland	1
France	2
Germany (Bavaria, Prussia, Saxony, etc.)	34
Holland	1
Italy	1
Mexico	54
Norway	1
Poland	2
Scotland	2
Spain	2
Switzerland	2
TOTAL	110

Immigrants with United States Origins (32%)

Alabama	3
Arkansas	4
Connecticut	1
Florida	1
Georgia	5
Illinois	1
Indiana	2
Kentucky	6
Massachusetts	2
Michigan	1
Mississippi	2
Missouri	2
New Hampshire	2
New Mexico	1
New York	7
North Carolina	10
Ohio	1
Pennsylvania	1
South Carolina	4
Tennessee	15
Virginia	4

Fig. 4. Origins of Early Texas Silversmiths.

Legend:
- Central Texas
- East Texas
- North Central Texas
- South Texas
- West Texas

1 Bosque	14 Austin	27 Cherokee	40 Montague	53 Goliad
2 McLennan	15 Bexar	28 Nacogdoches	41 Grayson	54 Victoria
3 Lampasas	16 Gonzales	29 Houston	42 Fannin	55 Matagorda
4 Bell	17 Lavaca	30 San Augustine	43 Denton	56 Refugio
5 Falls	18 Colorado	31 Walker	44 Collin	57 Calhoun
6 Williamson	19 DeWitt	32 Trinity	45 Parker	58 Webb
7 Milam	20 Lamar	33 Jasper	46 Tarrant	59 Duval
8 Gillespie	21 Red River	34 Montgomery	47 Dallas	60 Nueces
9 Travis	22 Marion	35 Harris	48 Kaufman	61 Zapata
10 Bastrop	23 Harrison	36 Fort Bend	49 Erath	62 Starr
11 Washington	24 Henderson	37 Brazoria	50 Ellis	63 Cameron
12 Caldwell	25 Smith	38 Galveston	51 Navarro	64 Pecos
13 Fayette	26 Rusk	39 Clay	52 Frio	65 El Paso

Fig. 5. Five Areas of Texas.

Where the 237 silversmiths lived and worked in Texas is an important part of this examination. For this analysis, the state was divided into five sections: Central Texas,[39] East Texas,[40] North Central Texas,[41] South Texas,[42] and West Texas[43] (fig. 5). Within these rough geographical divisions, silversmiths were found to work in nineteen Central Texas counties,[44] nineteen East Texas counties,[45] thirteen North Central Texas counties,[46] twelve South Texas counties,[47] and two West Texas counties[48] (fig. 6).

Not surprisingly, the majority of the identified silversmiths worked in the central, eastern, and southern parts of the state, the areas that developed first and were the most heavily populated in the nineteenth century. El Paso and Pecos Counties were the only areas in the western part of Texas where there were silversmiths, and that number was small. The largest concentration of active silversmiths was found in the population centers of the state at that time: Austin, Brownsville, Galveston, Houston, Marshall, and San Antonio.

Central Texas represents the very heart of the development of the state, and, consequently, this area evidences the most activity by nineteenth-century Texas silversmiths. The censuses in nineteen counties in Central Texas recorded 90 silversmiths working prior to 1880. (fig. 7). The greatest activity occurred in Bexar

Early Texas Silversmiths by Geographical Area n = 237

Geographical Area	Number	Percentage
Central Texas	90	38%
East Texas	56	24%
North Central Texas	31	13%
South Texas	52	22%
West Texas	4	1.5%
Unknown	4	1.5%

Fig. 6. Early Texas Silversmiths by Geographical Area.

Central Texas Silversmiths by Counties (19) n = 90

County	Number of Silversmiths
Austin	1
Bastrop	3
Bell	3
Bexar	41
Bosque	1
Caldwell	2
Colorado	3
DeWitt	1
Falls	1
Fayette	2
Gillespie	1
Gonzales	3
Lampasas	1
Lavaca	2
McLennan	1
Milam	1
Travis	14
Washington	4
Williamson	4
Robertson's Colony	1

One individual lived in two different counties in Central Texas, Milam and Williamson; he is counted in Milam, county of first residence.

Three individuals lived in two or more different counties, one or more in Central Texas, and one in East Texas (Fayette [Central] / Harris [East]; Travis [Central] / Washington, & Harris [East]; Travis [Central] / Fort Bend [East]); counted in county of first residence in Central Texas.

Fig. 7. Central Texas Silversmiths by Counties.

County, where 41 silversmiths worked. Most of this activity was in San Antonio which has a long and rich tradition in Texas history. Developing out of the Spanish Villa of San Fernando de Bexar, it was the first civil settlement in Texas, dating from 1731.[49] The 41 silversmiths in Bexar County included several individuals who worked in San Antonio in the late 1700s and early 1800s. However, most of the silversmiths worked there in the mid-to-late 1800s. San Antonio also claims the best-known of the Texas silversmiths, Samuel Bell and his sons—Jessup, David, Fetterman, and Powhattan (or Paul). Travis County, and primarily Austin, was home to 14 silversmiths; Washington and Williamson counties had 4 each; and the remaining fifteen counties had from 1 to 3 each.

The nineteen East Texas counties claimed 56 silversmiths (fig. 8). The earliest East Texas silversmiths worked in the Jurisdiction of Nacogdoches during the days of colonization. José Cervantes was identified as a silversmith on a 1792 census, and José Hipolito Domingues was listed on a 1797 census of that area.

Galveston County had a larger number (10) of silversmiths than any other county in East Texas. The city of Galveston was founded in the 1830s and became a "Texas metropolis during the period of the Republic and early statehood."[50] Five of the 10 silversmiths were there as early as 1850.

On the eastern border of Texas, Harrison County is bounded on the north and northeast by the Little and Big Cypress Bayous and Caddo Lake and on the south partly by the Sabine River. Because of its accessibility via water, stage, rail and ox freight lines, Harrison County became the third most populous and one of the wealthiest in Texas by the 1860s.[51] It claimed 8 silversmiths. One silversmith was identified on the 1850 U. S. Population Census, 4 in 1860, and 3 in 1870. All worked in the city of Marshall, with one, E. L. Trickey, moving to Jefferson, Marion County, shortly after the 1860 census was enumerated.[52]

Harris County had 7 silversmiths. Rusk County had 5, and Smith and Walker Counties had 4 each. The remaining 12 counties had 1 or 2 silversmiths each.

In thirteen counties of North Central Texas, the presence of 31 silversmiths was recorded. This area had no major population centers prior to 1880, so the silversmiths were scattered throughout the area. Kaufman County had the largest number with 7, and Collin and Ellis Counties followed with 4 each. The remaining 10 counties had 1 to 3 silversmiths each (fig. 9).

East Texas Silversmiths by Counties (19) n = 56

County	Number of Silversmiths
Brazoria	1
Cherokee	1
Fort Bend	1
Galveston	10
Harris	7
Harrison	8
Henderson	1
Houston	1
Jasper	2
Lamar	1
Marion	*
Montgomery	2
Nacogdoches	2
Red River	1
Rusk	5
San Augustine	2
Smith	4
Trinity	1
Walker	4
Jurisdiction of Nacgodoches	2

*One individual lived in two different counties in East Texas, Harrison and Marion, counted in Harrison, county of first residence

One individual lived in both Rusk & Smith Counties; counted in county of first residence

Fig. 8. East Texas Silversmiths by Counties.

In South Texas, 52 silversmiths are known to have worked in twelve counties during the nineteenth century. In the 1850 U.S. Census, the populations of Cameron, Starr, and Webb Counties were not enumerated separately, even though all three counties were founded in 1848.[53] No doubt the sparse population in these counties dictated combining them, but it makes reporting by county more challenging. The 3 individuals identified in the 1850 census who worked in these counties all lived and practiced their craft in Rio Grande City, the county seat of Starr County, so they are counted there. In the 1860 census, the counties were

North Central Texas Silversmiths by Counties (13) n = 31

County	Number
Clay	1
Collin	4
Dallas	2
Denton	1
Ellis	4
Erath	1
Fannin	3
Grayson	3
Kaufman	7
Montague	1
Navarro	2
Parker	1
Tarrant	1

Three individuals lived in more than one county in North Central Texas (Ellis, Parker, and Ellis); all are listed in their first county of residence.

Fig. 9. North Texas Silversmiths by Counties.

enumerated separately. The greatest concentration of silversmiths was in Cameron County and in the City of Brownsville, which had 16 active silversmiths. Webb County had 7 silversmiths; Starr County had 6 plus the 3 that were in the combined county enumeration for a total of 9; and Duval and Nueces Counties had 5 each. The remaining seven counties had 1 to 3 silversmiths each. As might be expected, the Hispanic culture and heritage was dominant in this area. With the exception of 7 of the 52 silversmiths who worked in South Texas, all had names traditionally associated with those of Hispanic origins (fig. 10).

South Texas Silversmiths by Counties (12) n = 52

County	Number
Calhoun	2
Cameron	16
Cameron, Starr, and Webb	*
Duval	5
Frio	1
Goliad	1
Matagorda	1
Nueces	5
Refugio	1
Starr	9
Victoria	3
Webb	7
Zapata	1

* The census enumeration for Cameron, Starr, and Webb Counties was combined in 1850. Since all three silversmiths identified in that combined census were from Starr County, they are counted there.

One individual lived in two counties in South Texas (Goliad and Atascosa); the silversmith was listed in their first county of residence.

Fig. 10. South Texas Silversmiths by Counties.

West Texas Silversmiths by Counties (2) n = 3

County	Number
El Paso	2
Pecos	1

Fig. 11. West Texas Silversmiths by Counties.

Not surprisingly, there were few silversmiths who worked in West Texas during the nineteenth century. Three silversmiths working in two counties were found. Two of those worked in El Paso and the third in Pecos County (fig. 11).

When the names of the individuals, their origins, and their places of residence and work in Texas were established, the next legs of the journey involved finding biographical information about each and identifying objects they produced. Both tasks have been challenging and slow and will likely continue for some time.

Collecting biographical information about the identified silversmiths is a difficult and tedious process. The goal is to develop as complete a chronology for each individual as possible. For most of the silversmiths, the search for biographical information usually began with the minimal amount of data provided on the census rolls, such as age, occupation, place of birth, and members of their household or the household in which they resided. County histories, city directories, and newspapers were important sources for this information as was Ancestry.com.[54] Another valuable tool was The Portal to Texas History,[55] a database which has more than a million pages of Texas historical information digitized and accessible on the Internet. Particularly useful from that source was the large number of newspapers that are available and easily searchable. Occasionally, generous descendants of the silversmiths being researched provided a great deal of information about their relevant family histories. The bottom line is that biographical information was and continues to be pieced together from whatever sources can be found. For some individuals, there is only a sentence or two of information; for others, a considerable amount has been discovered.

To demonstrate this process, tracking one individual as an example will show how the research evolved. Josiah Bishop was identified on the 1860 U.S. Census as a silversmith working in Austin, Travis County. The census data provided his age, fifty-eight, and his birthplace, South Carolina. It also indicated that his household included his wife, Lucy H. Bishop, born in Massachusetts, and their five-year-old son, H.F., born in Texas. The value of his real estate was reported as $640, and the value of his personal estate was reported as $250. The 1870 U.S. Census confirmed that Josiah Bishop was still living in Austin with his wife, Lucy; however, he was now listed as a watchmaker. There was no mention of his son. His real estate was valued at $1,000, and his personal estate at $200. J. Bishop was also listed on the 1870 Products of Industry U.S. Census as a watchmaker and repairer of watches and clocks. His business had been in operation for at least a year; his materials were valued at $50, and his products—namely repair on watches and clocks—were valued at $600. With this basic information, the search to find out more about this particular individual led to other sources. According to cemetery records, Bishop was born on August 13, 1801, and died in Austin on September 23, 1871.[56] By consulting nineteenth-century newspapers in The Portal to Texas History, it was established that he was in Texas and had a shop in Houston as early as 1837 because of an encounter with a thief. Bishop posted a notice in the *Telegraph and Texas Register* offering a $20 reward to find a Mr. A. Youry who stole a thin Elippine watch from his shop in Houston.[57] According to the notice: "Said Youry had been seen on the Brazos River, and said that he was going to Valesco; he is a tall man, black hair, rather stooped shouldered; has been in the army, and has been afterward whipt for stealing. I will give the above reward for him or the watch."

Because of an announcement in the *Telegraph and Texas Register* in 1838,[58] it is known that Josiah Bishop formed a business partnership with J. F. Parker prior to 1838; the announcement indicated that a "partnership heretofore existing between J. Bishop and J. F. Parker is this day dissolved by mutual consent." The notice indicated that "All persons indebted to the establishment are requested to call and settle the same with Parker & Seymeur, by whom the business will be continued." Bishop encountered problems with thieves again in October 1838, as he ran a notice in the *Telegraph and Texas Register*[59] offering a $100 reward for the "apprehension of the thief or thieves who entered my silversmith shop on Friday evening, September 21st. . . by means of false keys and purloined there from a large amount of property," including more than twenty watches which were described in some detail in the

notice. It concluded with "The above reward [$100] will be given and necessary expenses paid for the detection of the thief or thieves so that they may be brought to justice, and the recovery of the property."

By the end of 1850, Bishop had relocated to Washington, Texas, as evidenced by his advertisements in the *Texas Ranger*[60] promoting his services as a "Watch-Maker, Silversmith & Jeweller." He was still in Washington in 1852 as indicated by his advertisements in *The Lone Star*,[61] which noted that he had on hand "one dozen gold pens, gold holders. . . . silver holders, various sizes; finger-rings; breast-pins; earrings; bracelets; lockets; gold and silver thimbles" plus a variety of other objects. Sometime in 1853, Bishop moved to Austin, a fact established by a notice in the *Tri-Weekly State Times*[62] in November 1853 stating that he had "located permanently in this city [Austin], and will clean, repair and warrant watches and clocks and repair Jewelry, Musical Boxes and Accordions." The same advertisement indicated that he had available "Jewelry, gold and steel pens, pocket and table knives. . . . candlesticks. . . . together with a great variety of other articles too tedious to mention which will be sold very low for cash only." His shop was located on Congress Avenue, two doors above the late Lamar Moore's brick house.

Other advertisements ran in 1854,[63] 1855,[64] and 1856.[65] A bit puzzling is an advertisement which he ran in *The Texas State Times* in 1857 which states that "the undersigned, having returned to Austin, may be found in his old shop, second door above L. D. Carzington's, Congress Avenue, where he will clean, repair and warrant clocks and watches, repair jewelry, musical boxes, cut notarial seals, &c, &c."[66] It is not clear where he was returning from since he was in Austin in 1856. Bishop advertised in *The Bastrop Advertiser*[67] in 1858, *The Democratic Platform, For the Campaign*[68] in 1859, the *State Gazette*[69] in 1859, and *The Southern Intelligencer*[70] in 1866, citing an Austin location for his business in all of these notices. He was also listed in Brown's *Annals of Travis County* as a "Jeweller" and businessman.[71] A creative individual, he held two U.S. patents, one for an Escapement for Timekeepers[72] and one for the Improvement in Machines for Extracting Cotton and Corn Stalks.[73] Bishop died in Austin on September 23, 1871.[74]

Through research of newspapers and other documents, it was established that Bishop worked as a silversmith and jeweler in three different locations in Texas over a period of more than thirty years. This information suggests that it is also highly likely that he was more of a jeweler and watchmaker/repairer than a silversmith. Nevertheless, this type of investigation is necessary on each person identified as a

potential silversmith. Understanding more about the varied activities of the self-identified silversmiths in the period provides a much more nuanced understanding of both silversmiths and other related craftsmen in nineteenth-century Texas.

Of course, what holds the greatest interest for any scholar of decorative arts is the location and identification of actual objects that can be attributed to a particular artisan. This portion of the journey has been plagued by the scarcity of silver. Because silver is very soft and vulnerable to damage, it must have a considerable amount of care to survive long periods of time. In everyday use, items may become broken or damaged and are frequently discarded or melted to find their way into another use. Objects are also easily lost or misplaced in a society which has become increasingly mobile. Yet, the small number of objects made in Texas which had already been identified in museum, historical, and private collections at the outset of the journey, provided hope and encouragement that additional items could be found.

The custom of silversmiths is to identify their wares with some distinctive mark. While the European tradition, particularly the English tradition, has a highly developed system for marking silver, the American tradition is not so sophisticated or systematic. Early American silversmiths generally marked their wares with a stamp indicating either their name or initials and sometimes their location. There was not a national, legal effort made to insure the quality of the silver used through a system of assaying until The Stamping Act of 1906 was enacted. With the passage of that act, the law required that American silver be marked with the word "sterling" to denote the .925 standard of purity. Prior to 1906, marking a piece "sterling," ".925," or "coin" (to represent the standard of silver coins) was at the discretion of the maker. While quite a few states had already adopted their own laws,[75] no such legislation existed in Texas. Likewise, the inclusion of a place of production in the marks of American silver was sporadic. While the place was indicated by some silversmiths, many did not include this. To attribute the identified name of a silversmith with a particular mark, particularly if the mark is the maker's initials, requires considerable information about the provenance of the piece bearing the mark. This is most accurately done when as much as possible is known about the maker and the object, underscoring the need to expand our knowledge about identified silversmiths and each of their works.

A small body of silver produced and/or retailed by nineteenth-century Texas silversmiths has been identified. Some are marked and some attributed. The largest amount of marked Texas work known to exist is by the Bell family of San Antonio (figs. 12, 13, 14). Marks on the known silver made and retailed by Samuel Bell and

his sons were numerous. The work by the senior Bell bears at least four different marks or variation in marks. One of the most common is S. Bell in Roman capitals stamped in a rectangular cartouche (fig. 12). Another mark added a stamped scroll on either side of the cartouche, while still a third mark flanked both sides of the cartouche with a sun crest. There is also a known piece of Samuel Bell silver which has one stamped scroll. Some pieces bear no mark at all. Several of his fine blades bear still different marks or no marks at all. It has been speculated by some that certain of these marks were used while he worked in Tennessee, while others were used on Texas-made silver. However, there is no substantial evidence to support this theory.

A small amount of the work of the following silversmiths is known to exist: Fred Allen (Galveston County)[76] (fig. 15), Adolph Bahn (Travis County),[77] G. W. Capron (Harris County),[78] A. B. Carter and S. D. Morrill (Gonzales County),[79] W. S. Cloyd (Collin County),[80] William Eubank (Williamson County),[81] C. J. Garner (Travis County),[82] Charles Hine (Bexar County) (fig, 16), O. Kolstad (Smith County) (fig, 17), Adolph Lungkwitz (Gillespie County),[83] Benjamin Vining (Cherokee County) (fig, 18). Additional work has been attributed to the following silversmiths: Thomas B. Harris (Montgomery County),[84] Albert Iankes,[85] Charles Iankes,[86] and Gustavus Adolphus Iankes[87] (Washington County), James "Jimmy" Eubank (Williamson County).[88]

The identification and attribution of a piece of silver to a maker is a major undertaking. As previously noted, identification is complicated by the changing pattern of silver production which occurred in the nineteenth century when individual craftsmen were being replaced by manufacturers and retailers.[89] The retailer who sold silver frequently made some of it, but usually did not make all of it. Nevertheless, retailers often advertised as silversmiths, frequently adding a mark of their own in place of or in addition to the manufacturer's or maker's mark. Determining the actual origin of nineteenth-century silver is, indeed, a complicated endeavor.

Each portion of this particular journey to learn more about nineteenth-century silver production in Texas has yielded essential information which is necessary for serious study of the silversmiths and the work they produced. Research to this point supports Warren's belief that there is a good deal more silver made in the South, even in Texas, than may have been previously thought. Although Texas may have been what Ima Hogg referred to as "an empire in itself," thanks to the expanding body of research on the material culture of Texas conducted over the last few decades, it may not be that far removed from or dissimilar to the rest of the nation.

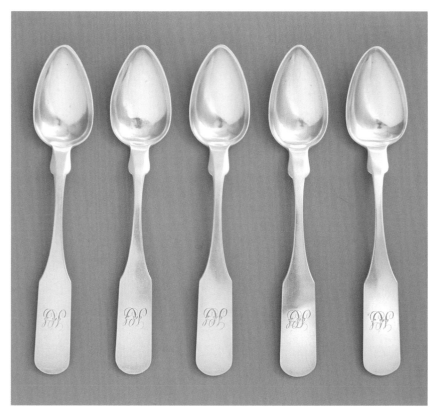

*Fig. 12. Samuel Bell, **Dessert Spoons**, silver, c. 1850, San Antonio, Bexar County, c. 1850, private collection.*

Detail, fig.12. Mark "S. Bell" in a rectangular cartouche on Dessert Spoon by Samuel Bell.

Fig. 13. Bell & Brothers, **Cup**, c. 1867, silver, San Antonio, Bexar County, Texas, United States, the Museum of Fine Arts, Houston, the Bayou Bend Collection, museum purchase funded by Alice C. Simkins, B.81.6.

Detail, fig. 13. Mark on Bell & Brothers Cup, c. 1867.

*Fig. 14. Bell & Brothers, San Antonio, Bexar County, **Teaspoons**, c. 1880, probably retailed by Bell & Brothers with mark of Coin and Bell & Brothers, private collection.*

Detail, fig. 14. Mark of Coin and Bell & Brothers on Teaspoons, c. 1880: Coin / Bell & Brothers.

*Fig. 15. Fred Allen, **Tablespoon**, c. 1870, Galveston County Texas, (probably retailed), photo courtesy of the Museum of Fine Arts, Houston.*

Detail, fig. 15. Mark on Fred Allen Tablespoon, c. 1870: "F. A. & Co., GAL. TX."

*Figure 16. Charles Hine, **Small Fork**, c. 1870,
San Antonio, Bexar County, private collection.*

*Detail, fig. 16. Mark on Charles Hine Small Fork,
c. 1870: Coin / C. Hine (incuse).*

*Figure 17. O. Kolstad, **Teaspoons**, c. 1850, Tyler, Smith County, private collection.*

Detail, fig. 17. Mark on O. Kolstad Teaspoon, c. 1850: incuse mark of O. Kolstad.

*Fig. 18. Benjamin Vining, **Teaspoons**, c. 1870, Rusk, Cherokee County, private collection.*

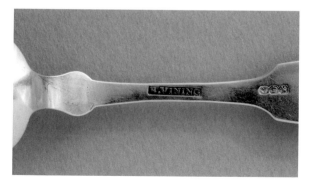

Detail, fig. 18. Mark on Benjamin Vining Teaspoon, c. 1870: B. Vining in a rectangular cartouche and a maker's mark attributed to Philo Dubois of New York, private collection.

Notes

1 David B. Warren, *Bayou Bend: American Furniture and Silver from the Bayou Bend Collection* (Houston: The Museum of Fine Arts, Houston, 1975), viii.

2 Georgeanna H. Greer and Harding Black, *The Meyer Family: Master Potters of Texas* (San Antonio: Trinity University Press, 1971).

3 Cecilia Steinfeldt and Donald Stover, *Early Texas Furniture and Decorative Arts* (San Antonio: Trinity University Press, 1973).

4 David B. Warren and Lonn Taylor, *Texas Furniture: The Cabinetmakers and Their Work, 1840–1880* (Austin: The University of Texas Press, 1975). A two volume revision of that work was published in 2012: *Texas Furniture, Volume 1: The Cabinetmakers and Their Work, 1840–1880*, rev. ed. (Austin: The University of Texas Press, 2012); *Texas Furniture, Volume 2: The Cabinetmakers and Their Work, 1840–1880* (Austin: The University of Texas Press, 2012).

5 Georgeanna H. Greer, *American Stonewares: The Art and Craft of Utilitarian Potters* (Atglen, PA: Schiffler Publishing, 1981).

6 Buie Harwood, *Decorating Texas: Decorative Painting in the Lone Star State from the 1850s to the 1950s* (Fort Worth: TCU Press, 1993).

7 Michael K. Brown, *The Wilson Potters: An African-American Enterprise in 19th-Century Texas* (Houston: Bayou Bend Collection and Gardens, The Museum of Fine Arts, Houston, 2002).

8 http://texasartisans.mfah.org/

9 http://www.caseta.org/

10 David B. Warren, "Southern Silver," *The Magazine Antiques* 99:3 (March 1971): 374–79.

11 David B. Warren, *Southern Silver* (Houston: The Museum of Fine Arts, Houston, 1968).

12 Warren, "Southern Silver" (1971), 374.

13 Examples: Sidney Adair Smith, *Mobile Silversmiths and Jewelers, 1820—1867*, 1970; Pilgrimage Garden Club of Natchez, *Natchez-made Silver of the Nineteenth Century*, 1970; Historic New Orleans Collection, *Crescent City Silver: An Exhibition of Nineteenth-Century New Orleans Silver*, 1980; *Silver from the Collection of the Birmingham Museum of Art*, 1982; Swannee Bennett & William B. Worthen, *Arkansas Made: A Survey of the Decorative, Mechanical and Fine Arts Produced in Arkansas, 1819–1870*, Vol. 1, 1990; John Bivins and Forsyth Alexander, *The Regional Arts of the Early South*, 1991; James R. Cormany, *Alabama Silversmiths, Little Known Craftsmen from a Long Forgotten Era*, 1992; E. Bryding Adams and Leah Rawls, *Made in Alabama: A State Legacy*, 1995; Patti Carr Black, *Art in Mississippi, 1720–1980*, 1998; Karen Klein Swager, *Palmetto Silver: Riches of the South; A Celebration of South Carolina Silver*, 2003; Norman Mack, *Missouri's Silver Age: Silversmiths of the 1800s*, 2005.

14 Warren, "Southern Silver," 374.

15 Alice Winchester, "Antiques," *The Magazine Antiques* 99:3 (1971): 373.

16 Charles L. Venable, *Silver in America, 1840–1940: A Century of Splendor* (Dallas: Dallas Museum of Art, 1944), 44.

17 Warren, *Bayou Bend: American Furniture, Paintings, and Silver from the Bayou Bend Collection*, 183.

18 Steinfeldt and Stover, 180–81.

19 Ralph M. Kovel and Terry H. Kovel, *A Directory of American Silver, Pewter and Silver Plate* (New York: Crown Publishers, Inc., 1976), 29, 242; Robert Morton, *Southern Antiques and Folk Art* (Birmingham: Oxmoor House, Inc., 1976), 105, 108–09; Steinfeldt and Stover, *Early Texas Furniture and Decorative Arts*, 254–55, 258–79; "Texas in the Union," *The Magazine Antiques* LIII:6 (1948): 449; Warren, *Southern Silver*, 79–81; Warren, "Southern Silver," 379.

20 Steinfeldt and Stover, 162–63, 168–73, 176–79, 254; Warren, "Southern Silver," 80.

21 Kovel and Kovel, 29; Steinfeldt and Stover, 162–63, 168–73, 177–79, 254; Noel D. Turner, *American Silver Flatware, 1837–1910* (New York: A.S. Barnes and Company, 1976), 242; Warren, *Southern Silver*, 80.

22 Steinfeldt and Stover, 162–63, 168–73, 167–79, 254; Warren, "Southern Silver," 80.

23 Kovel and Kovel, 55; Steinfeldt and Stover, 180–81; "Texas in the Union," 449.

24 Steinfeldt and Stover, 184–85, 255–56.

25 Ibid., 182–83.

26 Kovel and Kovel, 55; Steinfeldt and Stover, 180–81; "Texas in the Union," 449.

27 J.D.B. DeBrow, *The Seventh Census of the United States: 1850*, 2 vols. (Washington, D.C: Robert Armstrong Printer, 853), 1:51.

28 J. C. G. Kennedy, *Population of the United States: 1860*, 2 vols. (Washington, D.C.: Government Printing Office, 1864), 491.

29 F. A. Walker, *The Statistics of the Population of the United States* (Washington D.C.: Government Printing Office, 1872), 681.

30 F. A. Walker & G. W. Seaton, *Statistics of the Population of the United States at the Tenth Census* (June 1, 1880). (Washington, D.C.: Government Printing Office, 1882), 772–73.

31 Twenty-nine were actually found on the census rolls.

32 Sixty-nine were actually found on the census rolls.

33 Forty-four individuals were actually found; a second reading of the rolls does not support the numbers indicated on the summary data. No logical explanation of this great discrepancy has been found.

34 The 1880 summary data for the tenth census did not differentiate between goldsmiths, jewelers, silversmiths, and watchmakers; rather 225 gold and silver workers and jewelers were reported as working in Texas at the time. A reading of the census rolls revealed only 50 of those 225 were identified as silversmiths or goldsmiths.

35 Selected U. S. Federal Census Non-Population Schedules, 1850–1880, http://search.ancestry.com/search/db.aspx?dbid=1276, accessed July 22, 2013.

36 *Nonpopulation Census Schedules for Texas, 1850–1880*, (NARA microfilm publication T1134, rolls 2–49), Records of the Bureau of the Census, Record Group 29, National Archives, Washington, D.C.

37 Carolyn Reeves Ericson, *Nacogdoches–Gateway to Texas: A Biographical Directory, 1773–1849* (Ft. Worth: Arrow/Curtis Printing Co., n.d.), 140.

38 Steinfeldt and Stover, *Early Texas Furniture and Decorative Arts*, 256.

39 Central Texas includes an area bounded on the east by a line from the east side of Hill County southeastward to Galveston Bay; on the south by a line from the center of Matagorda County westward to the Frio/Zavala County line; on the west by Frio, Medina, Bandera, Kerr, Gillespie, Llano and San Saba counties, and on the north by Mills, Hamilton, Bosque and Hill Counties.

40 East Texas is defined as that part of the state which "may be separated from the rest of Texas roughly by a line extending from Red River in north Central Lamar County southwestward to east central Limestone County and then southeastward to Galveston Bay." Walter Prescott Webb, ed., *The Handbook of Texas* (2 vols.). (Austin: The Texas State Historical Association, 1952), 534.

41 North Central Texas is defined as the area bordered on the north by the Red River, on the east by a line running from the Red River southwest to Navarro County, on the south by Navarro, Ellis, Johnson and Hood counties, and on the west by a line running north from Hood County to the Red River.

42 South Texas area is bounded on the west and south by the Rio Grande River, on the east by the Gulf of Mexico, and on the north by a line running from the center of Matagorda County due west to the Rio Grande River.

43 West Texas is defined as the area west of a line from Wichita County on the Red River to Maverick County on the Rio Grande River.

44 Austin, Bastrop, Bell, Bexar, Bosque, Caldwell, Colorado, DeWitt, Falls, Fayette, Gillespie, Gonzales, Lampasas, Lavaca, McLennan, Milam, Travis, Washington, Williamson.

45 Brazoria, Cherokee, Fort Bend, Galveston, Harris, Harrison, Henderson, Houston, Jasper, Lamar, Nacogdoches, Marion, Montgomery, Red River, Rusk, San Augustine, Smith, Trinity, Walker.

46 Clay, Collin, Dallas, Denton, Ellis, Erath, Fannin, Grayson, Kaufman, Montague, Navarro, Parker, Tarrant.

47 Calhoun, Cameron, Duval, Frio, Goliad, Matagorda, Nueces, Refugio, Starr, Victoria, Webb, Zapata.

48 El Paso, Pecos.

49 Webb, 550.

50 Ibid., 662.

51 http://harrisoncountytexas.org/?p=63, accessed January 5, 2014.

52 *Texas Republican* (November 17, 1860), 6.

53 *Handbook of Texas Online,* http://www.tshaonline.org/handbook/online/articles/hcw05, http://www.tshaonline.org/handbook/online/articles/hcc04, http://www.tshaonline.org/handbook/online/articles/hcs13, accessed September 9, 2013.

54 http://www.ancestry.com/

55 http://texashistory.unt.edu/

56 Josiah Bishop, http://www.findagrave.com/cgi-bin/fg.cgi?page=gr&GRid=62403808, accessed September 12, 2013.

57 Borden & Moore, *Telegraph and Texas Register* (Houston), vol. 2, no. 21. ed. 1, Thursday, June 8, 1837, The Portal to Texas History, http://texashistory.unt.edu/ark:/67531/metapth47934/, accessed June 21, 2013.

58 Cruger & Moore, *Telegraph and Texas Register* (Houston), vol. 3, no. 33, ed. 1, Saturday, June 16, 1838, The Portal to Texas History, http://texashistory.unt.edu/ark:/67531/metapth47997/, accessed June 21, 2013.

59 Cruger & Moore, *Telegraph and Texas Register* (Houston), vol. 4, no. 6, ed. 1, Saturday, October 6, 1838, The Portal to Texas History, http://texashistory.unt.edu/ark:/6731/metapth48013/, accessed February 26, 2014.

60 J. Lancaster, *Texas Ranger* (Washington, TX), vol. 2, no. 28, ed. 1, Monday, December 2, 1850, The Portal to Texas History, http://texashistory.unt.edu/ark:67531/metapth48761/, accessed July 7, 2013.

61 J. W. Wynne, *The Lone Star* (Washington, TX), vol. 4, no. 6, ed. 1, Saturday, November 6, 1852, The Portal to Texas History. http://texashistory.unt.edu/ark/67531/metapth181337/, accessed June 24, 2013.

62 John S. Ford, *Tri-Weekly State Times* (Austin), vol. 1, no. 6, ed. 1, Friday, November 25, 1853, The Portal to Texas History, http://texashistory.unt.edu/ark:/67531/metapth 181710/, accessed June 21, 2013.

63 John S. Ford, *The Texas State Times* (Austin), vol. 1, no. 6, ed. 1, Saturday, January 7, 1854, The Portal to Texas History, http://texashistory.unt.edu/ark:/67531/metapth235722/, accessed June 21, 2013; John S. Ford, *The Texas State Times* (Austin), vol. 2, no. 2, ed. 1, Saturday, December 9, 1854, The Portal to Texas History, http://texashistory.unt.edu/ark:/67531/metapth235738/, accessed June 21, 2013; John S. Ford, *The Texas State Times* (Austin.), vol. 2, no. 4, ed. 1, Saturday, December 23, 1854, The Portal to Texas History, http://texashistory.unt.edu/ark:/67531/metapth235740/, accessed June 21, 2013; W. S. Oldham and John Marshall, *Texas State Gazette* (Austin), vol. 6, no. 18, ed. 1, Saturday, December 23, 1854, The Portal to Texas History, http://texashistory.unt.edu/ark:/67531/metapth81166/, accessed June 21, 2013.

64 John S. Ford, *The Texas State Times* (Austin), vol. 2, no. 11, ed. 1, Saturday, February 17, 1855, The Portal to Texas History, http://texashistory.unt.edu/ark:/67531/metapth235747/, accessed June 21, 2013,

65 John S. Ford and William E. Jones, *The Texas State Times* (Austin), vol. 3, no. 10, ed. 1, Saturday, February 16, 1856, The Portal to Texas History, http://texashistory.unt.edu/ark:67531/metapth235796/, accessed June 21, 2013; John S. Ford, *The Texas State Times* (Austin), vol. 3, no. 52, ed. 1, Saturday, December 6, 1856, The Portal to Texas History, http://texashistory.unt.edu/ark:/67531/metapth235841, accessed June 21, 2013.

66 John S. Ford, *The Texas State Times* (Austin), vol. 4, no. 16, ed. 1, Saturday, April 25, 1857, The Portal to Texas History, http://texashistory.unt.edu/ark:/67531/metapth235835/, accessed June 21, 2013.

67 William J. Cain, *The Bastrop Advertiser* (Bastrop, TX), vol. 6, no. 13, ed. 1, Saturday, May 29, 1858, The Portal to Texas History, http://texashistory.unt.edu/ark:/67531/metapth204543/, accessed June 25, 2013.

68 John Marshall, *The Democratic Platform: For the Campaign* (Austin), vol. 1, no. 13, ed. 1, Thursday, July 14, 1859, The Portal to Texas History, http://texashistory.unt.edu/ark:/67531/metapth78331/, accessed July 7, 2013.

69 John Marshall, *State Gazette* (Austin), vol. 10, no. 32, ed. 1, Saturday, March 19, 1859, The Portal to Texas History, http://texashistory.unt.edu/ark:/67531/metapth81379/, accessed June 21, 2013.

70 *The Southern Intelligencer* (Austin), vol. 1, no. 33, ed. 1, Thursday, February 15, 1866, The Portal to Texas History, http://texashistory.unt.edu/ark:/67531/metapth180035/, accessed July 7, 2013.

71 *Brown's Annals of Travis County*, 1853–54 (vol. 6), 1857–58 (vol. 7), 1859 (vol. 8), 1867 (vol. 9), and 1869 (vol. 10).

72 Josiah Bishop, Escapement for Timekeepers, patent, October 12, 1858 (original located in the University of North Texas Libraries Government Documents Department, Denton, TX), The Portal to Texas History, http://texashistory.unt.edu/ark:/67531/metapth165062/, accessed June 21, 2013.

73 Josiah Bishop, Improvement in Machines for Extracting Cotton and Corn Stalks, patent, February 19, 1861(original located in the University of North Texas Libraries Government Documents Department, Denton, TX), The Portal to Texas History, http://texashistory.unt.edu/ark:/67531/metapth165115/, accessed June 21, 2013.

74 Josiah Bishop, http://www.findagrave.com/cgi-bin/fg.cgi?page=gr&GRid=62403808, accessed September 12, 2013.

75 Sterling Silver, http://www.sterlingflatwarefashions.com/Msc/Metals.html, accessed May 13, 2013.

76 Warren, *Bayou Bend: American Furniture, Paintings, and Silver from the Bayou Bend Collection*, 183.

77 Steinfeldt and Stover, *Early Texas Furniture and Decorative Arts*, 180–81.

78 A teaspoon in a private collection, probably retailed by G. W. Capron, is marked with G. W. Capron in Roman letters in a rectangular cartouche.

79 Ibid.

80 EBay, September 14, 2008.

81 EBay, unknown date.

82 EBay, June 16, 2013.

83 Steinfeldt and Stover, 182–83.

84 A set of lodge jewels and a receipt for the silver which was rendered to make the jewels are in the Texas Masonic Museum in Waco.

85 Steinfeldt and Stover, 184, 185, 255.

86 Ibid., 184, 185, 256.

87 Ibid.

88 Seven pieces of silver, a butter spreader, and six teaspoons which are in the Daughters of the Republic of Texas Museum are attributed to Jimmy Eubank.

89 Alice Winchester, "Antiques" *The Magazine Antiques* 99:3 (1971): 373.

Have Camera, Will Travel: Itinerant and Immigrant Photographers in Early Texas

David Haynes

Most photographs taken today are made on cell phones. It is unlikely that many of these will survive very long as they become lost in the massive, ever-growing stream of digital data, but the few that are available one hundred years or more from now will be of great value to scholars interested in how people looked and lived at the beginning of the twenty-first century. Current historians can derive a great deal of information about nineteenth- and twentieth-century life from the photographs that have come down to us, particularly from places that were on the frontier and for which comparatively few other sources of information are available. Many of the early Texas photographers were immigrants or itinerants or both, and detailing the activities of a few of these may help us understand and appreciate how these artists were important, if unaware, contributors to the knowledge of our history and heritage.

Photography, which was developed in the early nineteenth century, was an immediate success and has directly touched the lives of almost every person in the world since. The details of the first practical process—the daguerreotype process—were announced in Paris in August 1839, and by September 27 of that year the first successful photograph had been made in the United States. The process, as initially developed by Louis-Jacques-Mandé Daguerre, required some fifteen to thirty minutes

Detail, fig. 20

Fig. 1. Louis-Jacques-Mandé Daguerre, **Boulevard du Temple***, c. 1838.*

for an exposure. A daguerreotype of a Paris street corner (fig. 1), made by Daguerre around 1838, is almost certainly the earliest photograph showing a human being. The scene seems to be totally deserted, but the daguerreotype was actually taken when the street was full of pedestrians, horses, wagons, and carriages; but none of these are visible on the plate because the original process was not light sensitive enough to record moving people and objects. The human being close to the intersection in the picture is visible because he was standing still for a long time while having his boots shined.

The French government obtained Daguerre's rights to the process by granting him a life pension and then magnanimously made the invention free for anyone in the world to use (with the exception of Great Britain, where Daguerre's agent quietly acquired a patent five days before the Paris announcement). While Daguerre invented the first practical photographic process, many other scientists, artists, and tinkerers improved its sensitivity so that pictures of human beings—the most popular use of photography then and now—could be made. These other workers succeeded quickly, and by late 1840 exposure times had been reduced to about thirty seconds.[1]

*Fig. 2. Unknown photographer, **Portrait of a Woman**, c. 1860, author's collection.*

The daguerreotype is the easiest photographic process to recognize. It is a camera original, meaning that the plate you hold in your hand was actually in the camera when the picture was exposed. The image, because it is composed of silver and mercury, presents different aspects when struck by light at different angles. It can be seen properly only at a particular angle to the light source. If it is tilted one way, it reflects back like a mirror. If it is tilted at another angle, the image appears to be negative. The daguerreotype is the only photographic process that has this quality. The plate will almost always be framed with a brass mat and a piece of glass and pressure fitted into a leather or gutta-percha case.

The first successful negative-positive photographic process, the calotype, which used paper as a base for negatives as well as prints, was announced in the same year as the daguerreotype and patented worldwide by its inventor William Henry Fox Talbot. He vigorously challenged anyone, amateur or professional, who used the process without buying a license. It was reasonably popular in Great Britain, where, since Daguerre's process was also patented, all users had to pay one license fee or the other; but the calotype did not enjoy much success in other countries.

Fig. 3. John P. Whipple, **Young Man Wearing a Bowler Hat**, *c. 1885, author's collection.*

The Langenheim Brothers of Philadelphia did buy the rights to use and license the process in the United States and subsequently sold the license for Texas and a few Southern states to Maguire & Harrington of New Orleans. So far, however, no evidence has surfaced to suggest that any negatives or prints using the process were made in Texas.[2]

About 1850, the Englishman Frederick Scott Archer discovered a way to attach a photosensitive emulsion to a glass plate. From then up until practically the turn of the century, almost all photographic negatives were made on glass plates. Archer's process was called wet collodion, and while it offered some advantages over the daguerreotype, it by no means immediately replaced the older process. However, by the late 1850s, in Texas as in practically everywhere else, the wet collodion process slowly began to gain favor.

The first use of this process that gained general acceptance was the ambrotype. An ambrotype is nothing more than an underexposed glass negative backed by something that is dark. So, like the daguerreotype, the plate that is exposed in the camera is the object sold to the customer. Ambrotypes were cased like daguerreotypes

Fig. 4. Attributed to William DeRyee, **Texas Troops at San Antonio at the Time of the Surrender of the U.S. Arms**, 1861, Daughters of the Republic of Texas Library at the Alamo, San Antonio.

Fig. 5. William DeRyee and Carl G. von Iwonski, **The Main Plaza San Antonio as Held by the Texas Volunteers under Col. Ben McCulloch in the Morning of the 16th February 1861**, 1861, original lost, copy courtesy of University of Texas at San Antonio Libraries Special Collections.

but were somewhat cheaper. They can be easily recognized on disassembly because they are simply underexposed negatives backed with black paper or paint or made on dark-colored glass (fig. 2).

The tintype is another kind of photograph made by the wet collodion process. Actually the term "tintype" is a misnomer, as the image is produced on an iron plate that has been lacquered to make it dark. These images were usually delivered to the customer in paper mats (fig. 3). The tintype came into general use during the Civil War, as it was easier and cheaper to mail. It reached its highest popularity in the 1860s and 1870s, but continued to be made on a commercial basis well into the twentieth century. A few photographers today use the process, basically as a novelty. The ambrotype, on the other hand, had a very short life and was widely abandoned by the end of the Civil War. Ambrotypes were generally produced between 1856 and 1865, and tintypes were mostly produced between 1860 and about 1890. Examples outside of those dates are somewhat uncommon.

Starting about 1856, a type of paper that could be used to make prints for customers from negatives that the photographer retained came into general use in

Fig. 6. E.A. Davis, **Jim and Joan Bainbridge.** *c. 1890, Jones Collection, DeGolyer Library, Southern Methodist University, Dallas.*

Texas and all over the world. This paper is called "albumenized" because the emulsion is suspended on the surface of the paper in egg albumen. The paper that was used is very thin, so pictures made on albumen paper are almost always mounted on cardboard. Prints on albumenized paper usually have a semi-gloss or satin surface. Since the physical appearance of albumenized paper is quite similar over its long period of use, images can be roughly dated by the size of the mount. The first mount to gain wide popularity was the carte de viste, about 2½ x 4 inches, introduced into the United States right at the beginning of the Civil War. By and large after 1875, prints on this mount size were replaced by those on the larger cabinet mount, 4¼ x 6½ inches, the dominant mount size until the first decade of the twentieth century.

But larger prints were always possible from photographers who had larger cameras, as exemplified by one of a series of San Antonio images (fig. 4) that are about 5 x 7 inch ovals mounted on cards that are roughly 9½ inches square. This photograph was probably taken by William DeRyee or Carl G. von Iwonski or Hermann Lungkwitz or some combination of the three, and the original negative was about 6½ x 8½ inches. The photograph purports to show Ben McCulloch's

Fig. 7. Printed back stamp for Arvin & Snydam, c. 1880, Jones Collection, DeGolyer Library, Southern Methodist University, Dallas.

State of Texas troops in San Antonio's Main Plaza after accepting the surrender of the U.S. Army troops and supplies under U.S. General David Twiggs and preparing to march against the federal frontier forts at the beginning of the Civil War. A drawing (fig. 5) that shows the same scene was made by Iwonski at the same time.

One of the obvious differences in the two images is that several flags appear in the drawing, while not one is visible in the photograph. It is reasonable to assume that at the time no flags representing the Texas troops were yet available; if they had been, the soldiers would certainly have displayed them. The artist could easily add flags to the drawing to enhance the patriotic feeling of the scene. These images can be used to demonstrate that the level of physical accuracy in photographs is often higher than that in other graphic representations. While drawings and engravings can more accurately render the emotional feeling of an event by adding or subtracting objects to support that feeling, the camera could record only the objects that were actually there at the time and place. This does not mean, of course, that a photographer could not rearrange objects in the scene, but the objects were real and were really there at the time. While it had been possible from the very beginning of photography to manipulate the process in either the camera or the darkroom to

show things that were not there when the picture was made, the effort involved required skills and resources that the average frontier photographer did not possess. This distinction applies only to early photographs, of course; today it takes but the press of a computer key or two to make a photograph show anything the user wants.

Now let me offer a thought or two on the definitions for our topic, namely the immigrant and itinerant photographers of early Texas. Since the earliest photographers in Texas arrived during the period of the republic, immigrants could include artists who came from such exotic places as, say, Ohio. But, for our purposes, I consider immigrants to be those born outside the United States as it existed in 1900. The bulk of this discussion will deal with this group because, frankly, the immigrants are somewhat more interesting, more is known about many of them, and they are easier to identify.

Itinerant photographers, on the other hand, are a little harder to characterize based on traditional definitions of itinerant practice, and their more frequent movement makes it more difficult to gather information about them. The vast majority of nineteenth-century Texas photographers practiced in more than one place, but most of them probably do not strictly qualify as workers who traveled from place to place, often along the same circuit, selling pictures as they traveled. But there are examples of picture takers who traveled to many Texas places, such as the mythical town of Anywhere, never establishing residency in any of them (fig. 6).[3] There are also other images made by photographers who worked a circuit in a general area while also maintaining a more-or-less permanent base (fig. 7).

Many itinerants simply traveled from town to town carrying their equipment and supplies in a wagon, rented a space, stayed a week or so, and then moved on the same way. Others set up wherever seemed appropriate using tents, photographic wagons, railroad cars, or the like. One of the few surviving Texas images that show these special "studios" records the tent used by the itinerant firm of Fey & Braunig (fig. 8).

Some traveling photographers should not be considered itinerants because they did not sell pictures to customers on the spot but made negatives of scenic places to be printed and sold back at their studios. Alexis Latourette photographed and sold stereo views in series called "Texas Scenery," which included images from both east and west Texas, but there is no evidence indicating that he ever opened a gallery in any Texas city. A stereo view believed to be of Fort Leaton, four miles down the Rio Grande from Presidio, includes the photographer's wagon (fig. 9). However, most

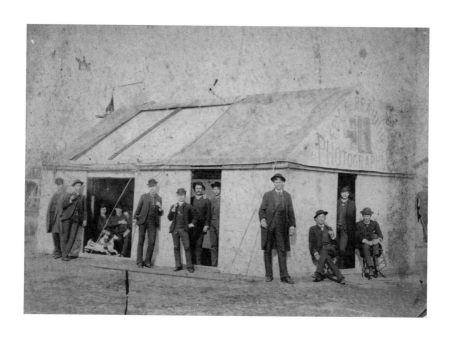

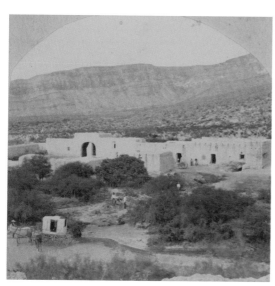

Fig. 8. Attributed to Pius Fey and Henry J. Braunig, **Fey & Braunig Tent Studio**, c. 1880, French Simpson Memorial Library, Hallettsville.

Fig. 9. Alexis Latourette, **Fort Leaton**, c. 1878, Jones Collection, DeGolyer Library, Southern Methodist University, Dallas.

Fig. 10. Printed back stamp for Frank Bailey, c. 1860, Jones Collection, DeGolyer Library, Southern Methodist University, Dallas.

Fig. 11. Printed back stamp for Michael Hartman, c. 1860, Jones Collection, DeGolyer Library, Southern Methodist University, Dallas.

photographers traveling around the state did take, process, and deliver portraits and scenics wherever there were customers, thereby qualifying as itinerant photographers. Nicholas Ankenman is a typical example. He was born in Canada in 1848, immigrated twenty years later, worked as an itinerant, and maintained a studio in Austin during the 1890s. Frank Bailey, with a variety of partners, had studios in Houston, Navasota, and Palestine at various times in the 1850s, 1870s, and 1880s. His "traveling" mount has a blank line where he could fill in the name of the town where he was working (fig. 10). Michael Hartman was in Grayson County in the 1870s and in Bonham in the 1880s, and he used an interesting back stamp for images he took while working as an itinerant that cleverly combined photography with traditional art both graphically and with words (fig. 11). Another example is John Hunzinker

who seems to have not had a home studio, paying occupation taxes as a photographer in the 1870s in Atascosa, Gillespie, Maverick, Starr, and Uvalde counties.[4]

The first photographer in Texas that can currently be documented is a Mrs. Davis, who advertised in Houston in late 1843. Nothing more is currently known about her. We do not know where she was born, where she came from, how successful she was in Houston, or where she went next. She may or may not have been an immigrant, but she was certainly an itinerant. Interestingly, an editorial mention about Davis in the Houston *Morning Star* does not suggest that she was the first photographer in the Bayou City, so it is possible that others preceded her.[5] As with a majority of photographers during the first fifty years after the advent of photography, Mrs. Davis came to town, took pictures as long as she had sitters (perhaps for two or three weeks), and then moved on to somewhere else.

J.H.S. Stanley was not an itinerant, but he was an immigrant.[6] He arrived in Houston from England with his wife and four children in 1845. Apparently he initially worked as a bookkeeper, and the earliest advertisement promoting his services as a photographer was published in the Houston newspapers in the summer of 1848.[7] In the notice, he emphasized that he had acquired his expertise in the new art from the most eminent amateurs and professionals in the United States and Europe. While he may have overstated his experience with practitioners on this side of the Atlantic, there is little doubt that he was familiar with the most advanced workers in England. We know, for instance, that he corresponded with the well-known daguerreotypists Antoine Claudet and Robert Hunt.[8] In addition, he subscribed to and contributed to the earliest photographic journals.

Fig. 12. **Daguerreian Gallery,** *November 7, 1851, Houston, Telegraph and Texas Register.*

Fig. 13. Unknown photographer, **William DeRyee**, *c.1855, private collection.*

Stanley advertised his photo gallery fairly consistently up until the beginning of the Civil War. The most interesting of these ads for the photo historian was published in fall 1851 (fig. 12). As mentioned earlier, the daguerreotype was largely replaced in the mid-to-late 1850s by ambrotypes and tintypes, but details of the process used to make these pictures, wet collodion, had actually been announced in early 1851. In this ad published a few months after that announcement, Stanley stated he intended to take portraits and views on glass, ivory, or paper. He would almost certainly have had to use the new process to make such images. As far as can be determined, Stanley was the only photographer outside of a very few in major U.S. cities to work with wet collodion before the mid 1850s. This is especially remarkable when one considers that at the time Houston was still a very small city. The 1850 census counted about 3000 Houstonians, which made it only the third most populous place in Texas. It would not be until 1900 that Houston had a larger

Fig. 14. William DeRyee, **Cotton Bond**, 1864, original lost, copy courtesy of University of Texas at San Antonio Libraries Special Collections.

population than Galveston, and it would take thirty more years for Houston to become Texas's largest city.

During the Civil War, business declined and advertising for Houston galleries ceased. We know that Stanley continued to operate, however, because the one existing photograph that can be attributed to him is a copy of a portrait of Stonewall Jackson made in 1863. But it is not really clear how active Stanley was after the war. While he continued to be listed in city directories and reported his occupation as photographer in the 1870 census, he was by that point an old man and in declining health. The fact that not a single photograph on a mount stamped with his name has surfaced indicates that he probably did not work very much after the paper print became the norm in the mid 1860s. But even so, when he died in 1872, Stanley had been a Texas photographer for more than twenty years, a remarkable record for that time and place.

*Fig. 15. William DeRyee, **John L. Haynes**, in* The Texas Album, of the Eighth Legislature, 1860, *1860.*

*Fig. 16. Carl G. von Iwonski, **Answer of the Germans to the Above**, February 8, 1868,* San Antonio Express.

The lives of the three short-term but important photographers mentioned earlier are equally interesting. In the 1840s, thousands of Germans immigrated to Texas. The first batch came as part of an organized colonization effort sponsored by a company of German nobles called the Adelsverien. Beginning in 1844, the bulk of these new settlers came to San Antonio and the Hill Country, establishing the towns of New Braunfels and Fredericksburg. After the failure of a raucous but mostly non-violent revolution in the German states in 1848, a slew of Teutonic activists, professionals, and intellectuals found it expedient to try their luck away from home. Many came to the United States, and quite a few ended up in Texas.

The only known daguerreotype portrait showing a nineteenth-century Texas photographer is of William DeRyee, who was a mineralogist, chemist, inventor, druggist, and photographer (fig. 13).[9] It was probably not taken in Texas because DeRyee did not arrive here until the very end of the daguerrean period in the late

Fig. 17. Hermann Lungkwitz, Calhoun County, 1871, History and Archives Division, Texas General Land Office, Austin.

CALHOUN COUNTY

1850s. He was born in Bavaria and immigrated to the United States after the 1848 revolution, locating first in Tennessee and Alabama where he explored for copper deposits and developed a cottonseed huller. After moving to San Antonio, DeRyee formed a partnership with the artist Carl G. von Iwonski to take and market paper photographs and glass lantern slides.[10] Iwonski was born in Silesia in 1830 and immigrated with his family to New Braunfels in 1845 as part of the Adelsverien. There he made pencil, ink, watercolor, and oil portraits of German settlers. In San Antonio, Iwonski and DeRyee combined art and photography. DeRyee claimed to have invented a photographic process he called homeography and used it to reproduce drawings, several by Iwonski, in quantity. During the Civil War, DeRyee operated a percussion cap factory in Austin, and Texas's cotton bonds were printed using his homeographic method (fig. 14).

In 1860, DeRyee was especially busy. He photographed every member of the Eighth Texas Legislature and most of the other state officials, and he published a book with glued-in photos featuring all of these leaders, including John L. Haynes, the representative from Starr County (fig. 15).[11] During the summer and fall of 1860, DeRyee traveled with two other San Antonio German artists, Hermann Lungkwitz and William Thielepape, exhibiting an extravagant magic lantern show

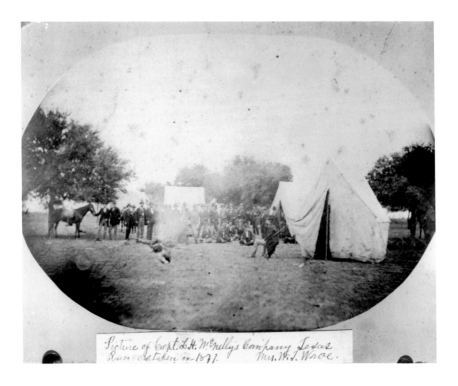

Picture of Capt. L.H. McNelly's Company Texas
Rangers taken in 1877. Mrs. W.J. Wroe.

Fig. 18. Unknown photographer, **Leander McNelly's Ranger Special Forces Company,** *c. 1875, copy print, Webb (Walter Prescott) Papers, The Dolph Briscoe Center for American History, University of Texas at Austin.*

on a tour that took them from Austin and New Braunfels up the Mississippi and Ohio rivers all the way to Wheeling, West Virginia.[12] Apparently the presentation was enthusiastically received in all of its venues. A reviewer for a St. Louis newspaper wrote about the first (of twenty-three) performances: "We can truly say, that there has never been an exhibition of any kind in this city, so magnificent and pleasing as the one at the Opera House now." A later review exhorted readers to "Go, See, Hear, and Wonder!" The final performance was in Indianola in January 1861. After the war, DeRyee became a respected druggist in Corpus Christi and also had a palatial home in Laredo.

While few copies of any of DeRyee's images have survived, one is especially notable because it may very well be one of the most rare photographic artifacts in the world: a homeographic print of a political cartoon by Iwonski was pasted onto the front page of every copy of the *San Antonio Express* on February 8, 1868 (fig. 16).

*Fig. 19. Louis de Planque, **John Salmon "Rip" Ford**, c. 1865, Jones Collection, DeGolyer Library, Southern Methodist University, Dallas.*

It is very difficult today to imagine what all those involved in the process—the artist, photographer, and publisher—could have been thinking. It would have been much easier and cheaper to reproduce the drawing as a wood engraving, so the only reasonable explanation seems to be that it was an experiment to prove that it was possible to use DeRyee's process for multiple newspaper copies. It is not surprising that the experiment was never repeated.

After the war, Iwonski set up a photographic studio in San Antonio with his friend and fellow artist Hermann Lungkwitz, who was born in 1813 in Saxony and settled with his family near Fredericksburg in 1852. While Iwonski was a self-trained artist who specialized in portraits, Lungkwitz had art training in Dresden and painted mainly landscapes. The photographic studio remained in business until 1870 when Lungkwitz moved to Austin to take a state job. Iwonski returned to Silesia in 1873 and died there in 1912.

Another German, who immigrated in 1849, possibly because of the 1848 revolution, was C.C. Stremme.[13] Born in Hanover, Stremme was educated as an engineer and architect and received several important honors in Germany and Russia.

Fig. 20. Louis de Planque Studio, **Louis de Planque**, *c. 1896, Corpus Christi Public Libraries.*

In 1855, he was appointed as a draftsman in the General Land Office and a year later designed and supervised the construction of the still-standing first Land Office building, on the southeast corner of the capitol grounds. In 1860, he experimented with making photographic copies of maps to sell to the public. A couple of examples of these maps still exist, but the effort seems to have been abandoned at the start of the Civil War. This is the earliest known example of any state government employee in the United States using photography as part of his official duties. Interestingly enough, the legislation that established this use of photography to copy maps provided that the land commissioner also investigate William DeRyee's homeographic system and pick one or the other.[14] Stremme remained with the Land Office until 1874 but did not, as far as is known, do any further work with photography. But in 1870, a fellow German immigrant, the previously mentioned Lungkwitz, was hired by the land commissioner to oversee (and serve as the lone employee of) the Land Office's newly established Photographic Bureau. Among the copies of his efforts that survive is a photograph of a map of Calhoun County

(fig. 17). When Reconstruction ended and the Democrats took back control of the state, Lungkwitz returned to San Antonio. He died in 1891.

In addition to the Land Office map copying effort, there is another instance of an early government photographer in Texas. Unfortunately, the primary source material provides little information about this endeavor. There is evidence of a Texas Ranger named A.L. Parrott who served under Leander McNelly in the Nueces Strip in the mid 1870s.[15] A photographic firm, Parrott & Quesenbeery, paid occupation taxes in the area at the same time.[16] Only one known photograph purports to show this Ranger unit, but neither the photographer nor the individuals included are identified (fig. 18). According to an 1898 article published in the *Evening Star*, Captain McNelly sent Parrott, a photographer in civilian life, up the Rio Grande with his photographic kit. People from all walks of life wanted to be photographed, and many of the customers talked about their exploits, including their criminal activities. Parrott kept copies of pictures of the bad guys and, back in camp, made up a mug book that allowed his fellow Rangers to identify hundreds of outlaws in short order.[17]

Fig. 22. Baker, **Three Men Aiming Guns at Calf on Ground***, c. 1900, Jones Collection, DeGolyer Library, Southern Methodist University, Dallas.*

Fig. 23. McArthur Cullen Ragsdale, **Views Around San Angelo, Texas***, c. 1885, Jones Collection, DeGolyer Library, Southern Methodist University, Dallas.*

Louis de Planque, a Frenchman born in Prussia who is known to have been in Mexico by the mid 1860s, is yet another fascinating Texas photographer.[18] No one now knows why he immigrated, but one can speculate that he came with the French incursion just for the adventure of it. After a short stint in Monterrey, by at least 1864, he opened a photo gallery in Matamoros and then another across the river in Brownsville. While the portrait business was de Planque's bread and butter (as it was for most photographers), he also took pictures of leaders and celebrities to sell to the public. His portrait of Rip Ford is the only known photograph of this famous Texan in a Confederate uniform (fig. 19). De Planque also made town views, and about a dozen of Brownsville and Matamoros from the 1860s survive today. After a hurricane in 1867 that seriously damaged de Planque's two galleries, he moved up the coast to Indianola and also operated in Corpus Christi, Refugio, and Victoria. When the great 1875 hurricane destroyed Indianola, de Planque, like practically everybody else, abandoned the town. For the rest of his life, de Planque operated his gallery in Corpus Christi. A couple of years before he died in 1898, de Planque, who came to be known in the area as Don Luis, was photographed in an elaborate costume that he wore during various celebrations, particularly Columbus Day (fig. 20).

McArthur Cullen Ragsdale was born in 1849 in South Carolina and moved with his family to a farm outside Killeen after the Civil War.[19] About 1870, Ragsdale bought a second-hand camera. There is some, though inconclusive, evidence that he worked with Belton photographer Charles Vanriper. In any event, using Belton as a base, he photographed along a circuit west on the Edwards Plateau that included Brownwood, Fort McKavett, Mason, and Fredericksburg, among others. In 1875, Ragsdale decided to set his enterprise up at Fort Concho in anticipation of steady business from the many soldiers involved in the final stage of the Indian Wars. Many of his portraits from this era, including those of Buffalo Soldiers, are unidentified (fig. 21). He basically settled down at the fort and then in the adjacent town, San Angelo, where he built a downtown building to house his studio and home. While he sent associates out to make pictures in the field (fig. 22) and probably did some of that sort of work himself, he increasingly became a settled, small-town photographer. In addition to his portrait work, he made scenic views in and around town (fig. 23). Ragsdale sold his business and retired about 1915. Soon after, almost all of his negatives were destroyed, and his work is known today only because a large number of prints produced during his long career were preserved by their owners and later by collectors. M.C. Ragsdale died in 1944 and is buried in an area overlooking the Concho River.

Fig. 24. Murray Montgomery, Fey & Braunig Studio, 2005, collection of the photographer.

And finally, an example of a long-term South Texas firm that brings together our two interests, immigrants *and* itinerants, is the firm of Fey & Braunig.[20] Pius Fey was born in 1855 in Prussia. After immigrating as a young man, he bought a photographic outfit from Max Krueger, a man who became quite successful in business after starting out as an immigrant itinerant photographer himself.[21] Fey worked a circuit in south central Texas from his base in Cuero. In the late 1870s, Fey taught Texas-born Henry J. Braunig photography, and the two became partners, establishing themselves as Fey & Braunig. In 1886, Braunig quit the circuit, moved to Hallettsville, and continued to operate there, using the firm name until the partnership was dissolved in 1909. In 1895, they built a two-story gallery and bookstore on the town square (fig. 24). There are relatively few portraits of early Texas photographers, and we are indeed lucky that an excellent one of Henry Braunig still exists (fig. 25).

Fig. 25. Fey & Braunig Studio, **Henry J. Braunig.** *c. 1890, private collection.*

Since Texas was a wide-open frontier during the middle of the nineteenth century that offered cheap land and boundless opportunity, it is only natural that it attracted settlers from far and wide. The republic, and then the state, attracted and benefitted from the influx of hordes of capable, intelligent newcomers, many of them from Mexico and Europe. These men and women contributed in great measure to developing the state we have inherited. A large number of these individuals practiced photography in their new home, providing mementos of the people, places, and events that were of importance to their customers and also valuable historical records of the era for generations to come. Since most localities could not offer enough customers to support a resident photographer, many artists traveled from place to place in order to generate sufficient business to make a living. As the population grew, more towns could support a photographer, and slowly itinerants settled into the normal life of Texas towns—both large and small. Modern students of Texas history owe a great debt to these early artists. The images they captured offer an invaluable window into the lives of ordinary Texans of the period.

Notes

1 The early history of photography has been extensively documented. General references include: Helmut and Alison Gernsheim, *The History of Photography from the Camera Obscura to the Beginning of the Modern Era*, rev. ed. (London: Thames & Hudson, 1969); Beaumont Newhall, *The History of Photography: From 1839 to the Present*, rev. ed. (New York: Museum of Modern Art, 1982); Naomi Rosenbaum, *A World History of Photography*, 4th ed. (New York: Abbeville, 2007); and Robert Taft, *Photography and the American Scene* (New York: Macmillan, 1938; Dover reprint, 1964).

2 David Haynes, *Catching Shadows: A Directory of 19th-Century Texas Photographers* (Austin: Texas State Historical Association, 1994), x.

3 This photograph and many others in this essay are from the Lawrence T. Jones III Collection, housed in Southern Methodist University's DeGolyer Library. Over a period of thirty years, Jones amassed more than 4000 images, most of them from nineteenth-century Texas. The DeGoyler Library acquired the collection in 2008 and has since digitized the images and made the files available on the Internet.

4 Haynes, *Catching Shadows*, 57.

5 *Morning Star* [Houston], December 12, 1843.

6 Substantial new information about Stanley has become available in the last few years, including the facts that he was born John Stanway and that he left England under somewhat of a cloud; he is the subject of ongoing research. Basic information can be found in James Bryan, "John Holt Stanway: Gone to Texas," *The Antiquarian Astronomer*, January 2008, 5–22.

7 *Democratic Telegraph & Texas Register* [Houston], November 9, 1848.

8 *Photographic Art-Journal* 3:3 (March 1852), 196.

9 Basic information on DeRyee can be found in Frank Wagner, "DeRyee, William," *Handbook of Texas Online* (http://www.tshaonline.org/handbook/online/articles/fde44).

10 Iwonski's life and career are detailed in James Patrick McGuire, *Iwonski in Texas: Painter and Citizen* (San Antonio: San Antonio Museum Association, 1976).

11 William DeRyee and R.E. Moore, *The Texas Album, of the Eighth Legislature, 1860* (Austin: printed by Miner, Lambert & Perry, 1860).

12 Lungkwitz's life and work are chronicled in James Patrick McGuire, *Hermann Lungkwitz: Romantic Landscapist on the Texas Frontier* (Austin: University of Texas Press, 1982). The magic lantern trip is discussed on page 21.

13 Basic information on Stremme is recorded in Clinton P. Hartmann, "Stremme, Christoph Conrad," *Handbook of Texas Online* (http://www.tshaonline.org/handbook/online/articles/fst74).

14 H.P.N. Gammel, *The Laws of Texas, 1822–1904* (Austin: Gammel-Statesman, 1904), 5: 283–85.

15 George Durham, *Taming the Nueces Strip: The Story of McNelly's Rangers* (Austin: University of Texas Press, 1962), 10.

16 Haynes, *Catching Shadows*, 85.

17 "The Texas Ranger," *Evening Star* [Washington, D.C.], May 13, 1898, 13.

18 Jerry Thompson and Lawrence T. Jones III, *Civil War and Revolution on the Rio Grande Frontier: A Narrative and Photographic History* (Austin: Texas State Historical Association, 2004), 8–15; Haynes, *Catching Shadows*, 33.

19 J. Evets Haley, *Focus on the Frontier* (Amarillo: Shamrock Oil, 1957), 19–26; Haynes, *Catching Shadows*, 90.

20 "Autobiography of H.J. Braunig," in Ava Crofford, *The Diamond Years of Texas Photography* (Austin: W.F. Evans, 1975), 62–65; Haynes, *Catching Shadows*, 15, 39–40.

21 Max Krueger, *Pioneer Life in Texas* (San Antonio: printed by Clegg, 1930).

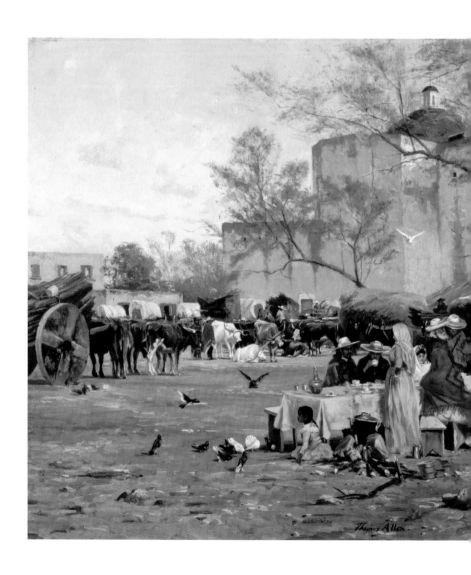

Fig. 1. Thomas Allen, **Market Plaza,** *1878–79, oil on canvas mounted on panel, Witte Museum, San Antonio, Texas.*

Thomas Allen's Sketches and Paintings of Texas, 1877–1879

Heather Elizabeth White

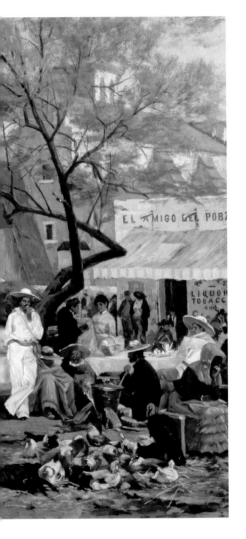

The year is 1878. As a locomotive makes its way down newly laid tracks to San Antonio, a twenty-nine year old man with a sketchbook in his lap gazes out the window at the Texas landscape rushing past. Like other nineteenth-century itinerant artists, this landscape painter, Thomas Allen (1849–1924), is traveling to Texas to paint and sketch its scenes and subjects.

Originally from St. Louis, the academically trained Allen studied at the Royal Academy at Düsseldorf, lived in an artists' colony in France, and traveled extensively in Europe and America before settling in Boston to focus on business and public service. While primarily a landscape painter, he also painted portraits and pastoral scenes. His work is romantic, bucolic, and emulates the Barbizon School style, which developed in France in the early nineteenth century.[1]

Over the years, Allen and his oeuvre have received less scholarly attention than other academically trained nineteenth-century American painters. More recently, a few of his paintings

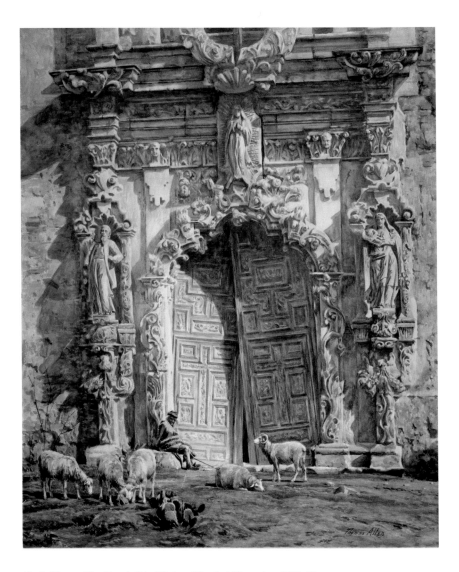

Fig. 2. Thomas Allen, **Portal of the Mission of San José, Texas,** *about 1878–82, watercolor on paper, the Museum of Fine Arts, Boston, gift of the artist, 12.326.*

have been shown in public collections, including *Market Plaza* (fig. 1) at the Witte Museum in San Antonio, *San Pedro Ford* at the San Antonio Public Library, and *Portal of the Mission of San José, Texas* (fig. 2) at the Museum of Fine Arts, Boston.[2] Because Allen was a businessman of considerable means, as well as a member of a wealthy family, he was not under financial pressure to sell his work during his lifetime. Therefore, many of his paintings, studies, and sketches remained in the private collections of his friends and descendants. As stated in a biography likely written not long after his death:

> He had in him the rare combination of artist and businessman, as he was a man of large means and investments, and painting was a side issue. . . . His work was exhibited all over the country and in the salons of Paris but it made little difference to him whether he sold his paintings or not. He was robust, good-natured, and very democratic. He was unconventional, and yet had great dignity.[3]

In the last few decades, new paintings and drawings have come to light and continue to be discovered. A significant number of his paintings and fourteen of his sketchbooks are housed in the Bobbie and John Nau Collection of Texas Art in Houston. This study is not a comprehensive look at Thomas Allen's oeuvre as it is known today, rather it examines the Nau Collection pieces, alongside related work from museums across the country in order to illustrate Allen's biography, explore his artistic accomplishments, and inform our understanding of his extended stays in Texas from 1877 to 1879.

Thomas Allen: A Brief Biography

Allen was born October 19, 1849, in St. Louis, Missouri. He was the son of the Honorable Thomas Allen and Annie Clementine Russell Allen.[4] Hailing from a long line of accomplished Americans, his ancestors were early settlers of New England.[5] Allen's father, Thomas Allen Sr. (1813–1882), was a United States congressman,[6] and, as the first president of the Missouri Pacific Railroad Company, he was also responsible for laying tracks for the first locomotive to cross the Mississippi River.[7] The artist's mother, Annie Clementine Russell Allen, was also well connected. She was the daughter of William Russell, one of the wealthiest men in St. Louis at the time.[8] It was through his mother's side that Allen was related to another accomplished artist, his second cousin Charles Marion Russell, who became famous for his paintings and sculptures of the American West. Both artists grew up in St. Louis,

and their grandfathers, James and William Russell, were brothers.[9] Although Allen was fifteen years older than his cousin, and despite the fact that the two men followed different artistic paths, they were surely aware of one another's work.

As a child, Allen lived in both St. Louis, where his father's business was based, and in Pittsfield, Massachusetts, the location of the family's homestead and summer retreat. He studied at Pittsfield High School and Williston Seminary. In 1867, Allen enrolled at Washington University, but was forced to discontinue his studies there in 1869 due to illness.[10] In the summer of the same year, he accompanied Professor James William Pattison on a sketching trip to the Rocky Mountains west of Denver.[11] The young Allen was inspired to pursue an artistic career following this trip. Pattison would continue to be an influential figure in his life. The two men later reconnected when Allen was studying in Germany and again when both artists moved to France.

In 1871, Allen traveled abroad, first visiting Paris, where he intended to pursue artistic training. However, many of the artists with whom he wished to study were absent from the French capital, most likely because Allen had arrived during the turbulent days of the Paris Commune. Therefore, he continued on to Germany, where he enrolled in the Royal Academy in Düsseldorf in 1872.[12] Allen joined the Academy with the intention of becoming a landscape painter and received a certificate confirming his chosen path of study.[13] In Düsseldorf, he studied with Andreas and Karl Müller and Eugen Gustav Dücker.[14] Dücker taught him to be a student of nature and told the young artist, "I teach you only composition and the use of pigment. Nature is your master for color and inspiration."[15] Allen's former teacher, Pattison, moved to Düsseldorf in 1873, because he believed "Düsseldorf surpassed both Munich and Paris for landscape work."[16]

Allen was an ambitious student, and the 1894 *National Cyclopedia of American Biography* tells this story:

He found the routine work presented by government direction too slow for the general purposes of his ambition and ignoring all rules, the impetuous American, by over study and surreptitious visits to forbidden classrooms, made such progress as to gain promotion into a most congenial class.[17]

A tintype from 1874 depicts the "impetuous American" as he would have appeared during his studies at the Academy in Düsseldorf (fig. 3). Allen spent his vacations during this period traveling throughout Europe and studying art in Holland, Belgium, Bavaria, France, and England.[18] He made his American artistic debut in 1876, when

he exhibited *The Bridge at Lissengen* in New York City at the National Academy of Design.[19] In 1877, he graduated and was encouraged to open a studio of his own.[20]

After graduating from the Royal Academy of Düsseldorf, Allen returned to his family home in Pittsfield.[21] For the next few years, he traveled between his family's estates in Missouri and Massachusetts, toured Europe, and lived in an artists' colony in Ecouen, France, where his companions included artists Edouard Frére, Luigi Chialiva, August Friedrich Albrecht Schenck, and others.[22] It was also during this time that Allen made his influential visits to Galveston and San Antonio. In 1879, Allen met his future wife, Eleanor Goddard Whitney, on an Atlantic voyage, possibly on a return journey from San Antonio to France. A drawing from one of Thomas Allen's sketchbooks may reference this event (fig. 4). In this sketch he depicts a couple casually conversing on what appears to be the deck of a ship.

Whitney was the daughter of Josiah Dwight Whitney, the state geologist of California. After marrying in Cambridge, Thomas and Eleanor lived together at the Ecouen colony, and their romance is detailed in a letters written by her father

Fig. 4. Thomas Allen, detail from **Sketchbook**, c. 1870–80, Bobbie and John Nau
Collection of Texas Art.

in the early 1880s.[23] In a letter dated 1882, he writes, "My daughter and her husband
returned to Europe and took up their residence at Ecouen near Paris, a favorite
resort of landscape painters. Here just a year ago, we found them living in idyllic
happiness, every possible blessing seeming to have been showered upon them."[24]
Yet this "idyllic happiness" was short lived. In 1882, tragedy struck the Whitney
and Allen families. Thomas Allen's father died in Washington, D.C., on April 8,
1882, while serving as a U.S. representative.[25] Thomas and Eleanor's daughter,
Eleanor Whitney Allen, was born ten days later on April 18, 1882. Less than a
month later, on May 14, Allen's wife died of complications following childbirth.
The day before Eleanor's death, her mother, Louisa Whitney, died at home in
the United States.[26]

A photograph from 1883 shows the family members left behind after this series
of tragic events: the two recent widowers, Thomas Allen and Josiah Whitney, along
with baby Eleanor Allen (fig. 5).[27] Following the deaths of his father, wife, and mother-
in-law within the span of only a few weeks, and with a newborn daughter to care
for, Allen returned to America and settled in Boston in 1882.[28] Allen remarried
in 1884, and he and his second wife Alice Ranney (d. 1949) had four children.[29]

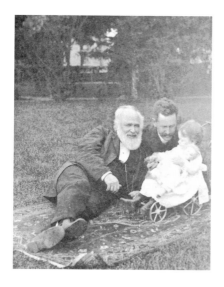

Fig. 5. *Josiah Dwight Whitney,* **Thomas Allen and Eleanor Allen,** *1883.*

Fig. 6. **Thomas Allen in His Studio,** *c. 1882–90.*

Allen's home and studio was located at 12 Commonwealth Avenue in Boston. The family spent summers at The Pines, their home in Princeton, Massachusetts. In a photograph from the turn of the century (fig. 6), Allen is seen in his studio surrounded by his paintings and his own collection of art and oddities. An 1888 text titled *Living New England Artists* describes Allen as

> . . . a man of means and artistic discrimination, his surroundings have always been of the most elegant and instructive nature, and his special knowledge of ceramics, the history of painting and decoration, and indeed of the fine arts in general has made his name well known as an intelligent and able connoisseur in the arts and handiwork of all times.[30]

In his later life, Allen was a social, business, and arts leader in Boston.[31] In 1893, he was judge of awards for the World's Columbian Exposition in Chicago, and in 1904 he served as chairman of the international jury of awards at the Louisiana Purchase Exhibition in St. Louis. As a businessman, Allen was president of the MacAllen Company of Boston, the Allen Estate Association of St. Louis,

*Fig. 7. Thomas Allen, page from **Sketchbook**, c. 1870–80, Bobbie and John Nau Collection of Texas Art.*

and the Wellesley Knitting Mills in Massachusetts.[32] Allen was involved with the Museum of Fine Arts, Boston, throughout his lifetime.[33] He was a museum committee member for many years and, on July 17, 1924, was elected president of the museum.[34] His life ended only a few weeks later, on August 25, 1924.[35] The *Boston Museum Bulletin* from 1924 celebrated Allen's character and contributions:

> Naturally courageous, he possessed a directness which, added to a kindly disposition, loosened many a knotty question fraught with friction, where a holly word and a genial laugh dispelled any possible misunderstanding. A good friend and true, a hard worker, reaching fearlessly and with great pains to the heart of the problem at hand, for he gave generously of his time.[36]

Thomas Allen's Sketchbooks

Thomas Allen's sketchbooks from his Texas tours and his travels along the East Coast and Europe provide invaluable insight into his life and artistic practice. Allen sketched on the spot, observing his fellow man, the life of cities, and the natural world. Evidence of his formal training at the Academy in Düsseldorf is also clear in

*Fig. 8. Thomas Allen, detail from **Sketchbook**, c. 1870–80, Bobbie and John Nau Collection of Texas Art.*

these books. One pen and ink sketch depicting men and horses is drawn in a romantic style, possibly referencing other nineteenth-century artists whose work Allen may have sketched on study trips throughout Europe (fig. 7). In another page from his sketchbooks, faint outlines appear to trace the route of his father's Saint Louis Iron Mountain and Southern Railway, showing stops in St. Louis, Chicago, Little Rock, and Mobile. Although the sketch does not show the connections in Texas, it is clear that Allen was thinking about railway journeys and his father's business. Likewise, a drawing of two sleepy gentlemen with their heads resting on comfortable chairs may have been sketched by the artist while riding the rails (fig. 8).

Allen was a thorough artist who created numerous sketches and watercolor studies before completing finished oil paintings. In a sketch (fig. 9) for a sunset scene, the artist has labeled the colors that he would use in a later oil painting (fig. 10). In *Sunset, South Texas, 1877,* a potential connection is found, where Allen appears to fully realize the "blue green, green, yellow, red, cool grey, and campfire yellow" he outlined in the drawing. As part of his process, he also left himself written reminders of details: for example, in a sketch of a horse drawn wagon, items in the back are labeled, "gurney sack and hay" (fig. 11). One can imagine Allen sketching scenes

*Fig. 9. Thomas Allen, page from **Sketchbook**, c. 1877, Bobbie and John Nau Collection of Texas Art.*

*Fig. 10. Thomas Allen, **Sunset, South Texas, 1877**, 1877, oil on canvas mounted on board, Bobbie and John Nau Collection of Texas Art.*

*Fig. 11. Thomas Allen, page from **Sketchbook**, c. 1877–79, Bobbie and John Nau Collection of Texas Art.*

from life and making the appropriate notes and reminders to guide the creation of finished paintings later.

Lists found throughout the sketchbooks provide a glimpse of the day-to-day life of the artist. Shopping lists for both art supplies and groceries enumerate items such as palette knives, sketching paper, a water bottle, chocolate, tea, wine, biscuit, and fruit. Budget lists include prices of items such as "cab 3.60, lunch 6.30, groceries 13.75 and books 10.50." A list of books features artistic titles, including *Art of Sketching from Nature* by P. H. Delamotte (1871), *The Great Painters of Christendom from Cimabue to Wilkie* (1877) by John Forbes-Robertson, and *The Works of J. M. W. Turner* (1877) by James Dafforne. The sketchbooks also contain hundreds of studies of people, plants, and animals. As a "lover of nature, possessing not only an intimate but a scientific knowledge of her trees and shrubs and flowers and other forms of growth,"[37] Allen was enthralled with the natural world he observed on his travels. In one sketchbook, pressed flowers are found between the pages.[38] Based on his involvement with the Horticultural Society in Boston later in life, it is clear that his love of nature was a lifelong passion. The artist was particularly fond of sketching cattle, and studies

of bovine subjects range from simple line sketches to full-color compositions. The nineteenth-century historian Frank T. Robertson remarked that Allen, in his observations of animals, "sees and carefully notes the docility and tender colors of animals, their movements, companionable groupings, and quiet contentedness in pasture life."[39]

Furthermore, the personality of the artist is expressed in humorous sketches. Although a serious and accomplished artist, Allen was also described by his contemporaries as gregarious and lighthearted:

> Domestically inclined, studious, unostentatious, and a delightful conversationalist, straightforward in his knowledge and convictions, and is well balanced all round. . . he sees the comic side of animal and human life, as well as the serious, and is thoroughly in love with his profession.[40]

His ability to see "the comic side of life" is apparent in playful drawings from the sketchbooks. On one page, a solitary figure reading a book appears to float in space, somewhere between the sun and the moon (fig. 12). In another sketch, a figure enthusiastically waves out the window. Labeled "Post prandial practice, Linden Gate Newport [Rhode Island], July 31st 1878," this scene may depict a post-dinner tradition of waving farewell to departing guests (fig. 13).

The Texas Tours

The well-traveled Allen enjoyed successful careers as both a businessman and an artist and created what may arguably be his most sophisticated and interesting works during the short time he spent in Galveston and San Antonio, Texas, in the winter of 1877–78 and the winter of 1878–79. Rather than focusing exclusively on the mythic cowboy often associated with Texas imagery, he faithfully illustrated Galveston and San Antonio along with their residents, many of whom were immigrants to the state, having arrived both from Mexico and many European countries.[41] Allen painted at a time when Texas was still forming an identity as a state and during a period when photography had only recently become more widely available. His paintings can serve as primary source documents which tell a story of Texas people and landscapes in the late 1870s.

According to Allen's widow Alice Ranney, "he was attracted to San Antonio as an artist, finding its picturesque features a wealth of material."[42] It would have been especially easy for Allen to travel by rail to Galveston and San Antonio in the late

Fig. 12. Thomas Allen, page from *Sketchbook*, c. 1870–80, Bobbie and John Nau Collection of Texas Art.

Fig. 13. Thomas Allen, **Post prandial practice, "Linden Gate" Newport, July 31 '78**, 1878, Bobbie and John Nau Collection of Texas Art.

Fig. 14. Thomas Allen, **Galveston, November 19, 1877**, 1877, oil on canvas
mounted on board, Bobbie and John Nau Collection of Texas Art.

1870s as a result of his family's connection to railroad development. Thomas Allen
Sr. became the first president of the Missouri Pacific Railway Company in 1850,
one year after the artist's birth.[43] In 1867, the year Allen began studies at Washington
University in St. Louis, his father bought the railroads between St. Louis, Arkansas,
and Texarkana, consolidating them under the Saint Louis, Iron Mountain and Southern
Railway.[44] The railroad connection between Galveston and San Antonio was completed
in 1877. According to a report published in the *San Antonio Express* in 1877, "San
Antonio was perhaps the largest city on the continent that had remained so long
without a railroad connection" and when it did arrive on February 19, 1877, it
transformed the "old dry bones of the city."[45]

In the fall and winter of 1877–78, Allen traveled by train to Galveston and
San Antonio, which were both major cities at the time. Historically, the island of
Galveston boasted the most successful port in the Gulf of Mexico between New
Orleans and Veracruz, Mexico. In 1870, it was the largest Texas city, with a population
of 13,800 people, and in 1880 the population had grown to 22,250. Allen visited
the vibrant city of Galveston in 1877, where he saw it at its peak, well before it was
dramatically changed by the hurricane of 1900.[46] Allen painted and sketched the

*Fig. 15. Thomas Allen, **Galveston Bay**, 1877, oil on canvas mounted on board, Bobbie and John Nau Collection of Texas Art.*

Galveston port and the surrounding landscape, providing an important visual record of the area as it appeared in the late nineteenth century. In a painting titled *Galveston, November 19, 1877*, a dirt road meanders into the gulf coastal plain of southern Texas (fig. 14). A single figure bends by the side of the road, and birds fly overhead. In another painting, *Galveston Bay*, boats float in the distance under a large sky (fig. 15).

Allen's sketches created during his visit to Galveston also depict the open bay with clouds over the ocean, as well as wharf scenes. In one such scene, men, women, and children congregate near the masts of boats; atop one flies the Texas flag, which in 1877 would have been the de facto symbol of the state (fig. 16). A completed *Galveston Wharf* painting likewise depicts the citizens of Galveston, their boats, horses, wagons, and wharf buildings (fig. 17).

Allen also visited San Antonio during his 1877–78 tour of Texas, returning there again in the fall of 1878 and staying through the winter. Perhaps he fled the heat of pre-air conditioned Texas summers, retreating to a cooler climate for the hottest months of the year and returning to Texas when the weather was again bearable. Much like Galveston, San Antonio was thriving at the time of his visit.

Fig. 16. Thomas Allen, page from **Sketchbook**, c. 1877–78, Bobbie and John Nau Collection of Texas Art.

Fig. 17. Thomas Allen, **Galveston Wharf**, 1877, oil on panel, Bobbie and John Nau Collection of Texas Art.

In 1880, it was the second largest city in the state behind Galveston.[47] San Antonio attracted many artists in the late nineteenth century who came to sketch and paint its robust culture and architecture.[48] One of Allen's friends was Robert Jenkins Onderdonk (1852 –1917), an influential and well-known Texas artist, who also worked in San Antonio during this time.[49]

A quickly drawn self-portrait from the sketchbooks depicts the artist with a small easel and the caption, "Il soir, sur la plaza a San Antonio Texas," which roughly translates from French to "Evening, on the plaza in San Antonio Texas."[50] Allen's work from San Antonio focuses on two major landmarks as well as landscapes outside the city: the mission of San José located south of the city, and the centrally located Military Plaza, also known as Market Plaza, along with the adjacent San Fernando Cathedral which was built in 1731.[51]

Market Plaza was home to a bustling commercial district when Allen visited in the late 1870s (fig. 18). In the morning, carts and covered wagons would have crowded the square where vendors sold fruits, vegetables, beef, venison, turkey, honey, and pecans. A visitor arriving by one of the first trains in the late 1870s described one such scene:

*Fig. 19. Thomas Allen, **Evening Market**, 1878–79, oil on canvas, Hunter Museum of American Art, Chattanooga, Tennessee, gift of Berniece and Henry Blount, Jr., HMAA.1993.37.*

Beneath an umbrella-tree that sheds powerful fragrance, little tables are spread, where the market people get their wool and chocolate and bit of pastry. . . vendors of bunches of magnolias, and great ineffably sweet Cape Jasmines, Mexican women half veiled by their rebozos surrounded by wicker cages full of [birds].[52]

The activity in Market Plaza continued throughout the evening. After vendors left taking their wares with them, the "chili queens" set up tables with oil cloth, flowers, and large colored tin lamps, where they served Mexican food. Both locals and out-of-town tourists came to enjoy the atmosphere and sample the cuisine. In 1890, a visitor to Military Plaza described a typical night in the plaza:

Imagine a large square at that time badly lighted as to municipal illumination, but ablaze with small camp fires and flaming lamps swinging above rows of improvised and shaky tables. All night long one might be served here with viands hot from the Mexican cuisine—Chili con carne, Tamales, Enchiladas, Chili Verde, frijoles, and the leather-like tortillas. The more fastidious American might enjoy delicately fried eggs and chicken with a cup of fair coffee, followed perchance by a corn shuck cigararro."[53]

Fig. 20. Thomas Allen, page from
Sketchbook, c. 1877–79, Bobbie and
John Nau Collection of Texas Art.

Fig. 21. Thomas Allen, page from
Sketchbook, c. 1877–79, Bobbie and
John Nau Collection of Texas Art.

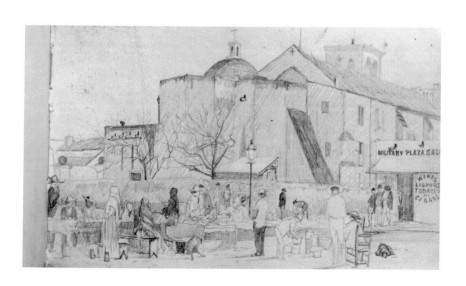

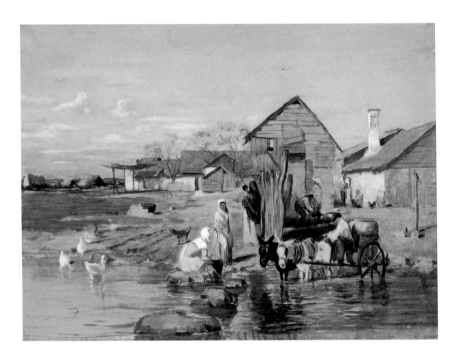

*Fig. 22. Thomas Allen, **San Pedro Ford**, 1878, watercolor on paper, Bobbie and John Nau Collection of Texas Art.*

Allen's painting *Market Plaza* (fig. 1) is considered his masterpiece. It was exhibited at the Paris Salon in 1882 and was copied by Onderdonk.[54] Allen's painting was purchased by the Witte Museum in 1936 and remains a part of the collection today.[55] In this work, Allen depicts San Antonio residents enjoying their daily activities. In the background, wagons and carts are lined up in front of San Fernando Cathedral; the dome and rear walls are visible behind the branches of an umbrella tree. Men and women dressed in serapes, rebozos, and sombreros dine al fresco. One man drinks a cup of coffee, and another stands nearby smoking a cigararro. In a recently discovered painting (fig. 19) in the collection of the Hunter Museum in Chattanooga, Tennessee, the plaza is shown at dusk after the vendors have left for the day, with only a few cattle and figures remaining. The moon is seen rising in the background over San Fernando Cathedral. Numerous studies for these paintings found in Allen's sketchbooks show different views of the plaza, cathedral, and nearby streets as observed by the young artist (figs. 20 and 21).

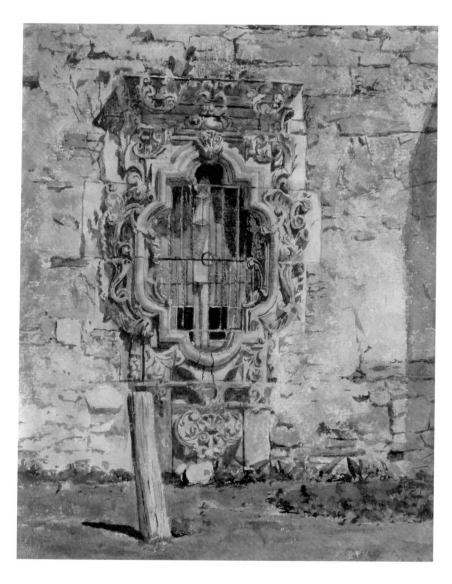

Fig. 23. Thomas Allen, **The Rose Window***, 1878, watercolor on paper, Bobbie and John Nau Collection of Texas Art.*

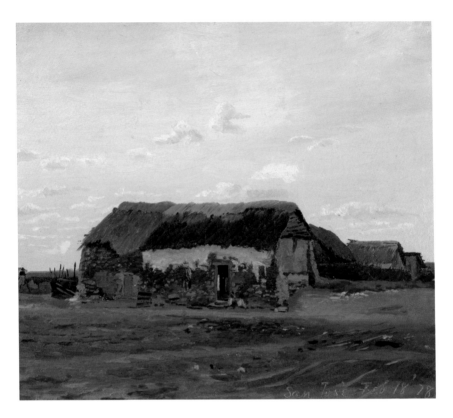

Fig. 24. Thomas Allen, **Jacals, Mission San José***, 1878, oil on canvas mounted on board, Bobbie and John Nau Collection of Texas Art.*

Along with views of Military Plaza and San Fernando Cathedral, scenes from San Pedro Creek and the Mission of San José appear in Allen's paintings and sketches. A watercolor study (fig. 22) for the painting *San Pedro Ford* resides in the Nau Collection, while the completed oil painting belongs to the San Antonio Public Library. In this painting, women draw water from the San Pedro Creek, and a water carrier is seen with his cart and donkeys.[56] Allen's extraordinary watercolors of the Mission of San José depict the architecture of this San Antonio area landmark, located a few miles south of the city center. Built in the early eighteenth century, the Mission San José was one of the first Spanish missions in San Antonio. When Allen observed the mission in 1878, it was in a state of disrepair; nevertheless the Holy Cross Fathers of Notre Dame continued to conduct services there.[57] Two detailed

Fig. 25. Thomas Allen, **Outskirts of San Antonio***, 1878, oil on canvas mounted on board, Bobbie and John Nau Collection of Texas Art.*

watercolors depict the famous *Rose Window* (fig. 23) and the elaborate *Portal* (fig. 2). The paintings *Jacals, Mission San José* (fig. 24) and *Outskirts of San Antonio* (fig. 25) capture the dwellings located near the mission. Jacals are traditional Tejano structures constructed with poles covered with mud or clay, plastered inside and out, and covered with thatched roofs.[58]

Allen also sketched and painted the landscape surrounding San Antonio (fig. 26). As with his views of Galveston, he painted the expansive skies and open spaces outside of the city, with hills visible in the far distance, and the fall and winter colors of these landscapes are reminders of the seasons in which Allen visited. Two of these paintings show the missions of San Fernando (fig. 27) and San José (fig. 28) from a distance, and in one painting of San Fernando, an American flag flies to the left of the cathedral over Military Plaza.

*Fig. 26. Thomas Allen, **San Antonio, December 15, 1877,** 1877, oil on paper mounted on board, Bobbie and John Nau Collection of Texas Art.*

*Fig. 27. Thomas Allen, **San Fernando Cathedral,** c. 1877–79, oil on paper mounted on board, Bobbie and John Nau Collection of Texas Art.*

*Fig. 28. Thomas Allen, **San José in the Distance**, c. 1877–79, oil on canvas mounted on board, Bobbie and John Nau Collection of Texas Art.*

In the years following Allen's tours, Texas would become increasingly connected to the rest of the country through the railroads and would experience dramatic economic and cultural change and growth as it continued to develop its identity as a state. Allen's paintings and sketches of Texas from 1877 to 1879 capture a specific moment in Texas history and preserve for posterity the landscape and the people he encountered on his travels during the post-Civil War period before the transformations that would be brought on by, among other factors, the lumber and oil booms of the coming years.

Notes

1 William H. Gerdts, *Art Across America: Two Centuries of Regional Painting 1710–1920, Volume 3* (New York: Abbeville Press, 1991), 46.

2 Cecilia Steinfeldt, *Art for History's Sake: The Texas Collection of the Witte Museum* (San Antonio: Witte Museum of the San Antonio Museum Association, 1993), 7.

3 Undated biographical typescript, Thomas Allen archival file, San Antonio Library, Texana Collection.

4 James Terry White, *National Cyclopedia of American Biography, Volume 5* (New York: J.T. White and Company, 1894), 318.

5 Allen's great grandfather, Thomas Allen (1743–1810), was a chaplain and well-known figure in the Revolutionary War. He earned the appellation the "fighting parson of Bennington fields" after he fired the first shot at the Battle of Bennington in Massachusetts. The artist's grandfather, Jonathan Allen (1773–1845), was a farmer and the founder of the Berkshire Agricultural Society.

6 The Allen men prided themselves on their ambition and self-reliance. According to family legend, after the family was crippled by cholera and financial disaster, Jonathan Allen said to his son, "I have given you an education, here are twenty five dollars. It is all that I can do, go and take care of yourself." Frank T. Robertson, *Living New England Artists: Biographical Sketches, Reproductions of Original Drawings and Paintings by Each Artist* (New York: S. E. Cassino, 1888), 14.

7 "Allen, Thomas, (1813–1882)," *Biographical Dictionary of the United States Congress, 1774–Present*, http://bioguide.congress.gov/scripts/biodisplay.pl?index=A000147.

8 Robertson, 15.

9 Allen's artistic abilities were said to come from his mother's side of the family, and Annie Allen encouraged her son to study art both at home and abroad. Anna Lee Ames Frohlich, "The Talented Thomas Allen and his Talented Cousin," *Colorado History, Western Footprints*, last modified February 21, 2013, http://coloradogambler.com/western-footprints-the-talented-thomas-allen-his-talented-cousin/.

10 Undated biographical typescript, Thomas Allen file, San Antonio Library.

11 Pattison was an American artist who taught at Washington University and who shared a studio with fellow artist William Merritt Chase in St. Louis. Gerdts, 46.

12 Pauline A. Pinckney, *Painting in Texas: The Nineteenth Century* (Austin: University of Texas Press, 1967), 185.

13 The text of a certificate issued by the Academy on January 11, 1873, reads: "This certifies that this student will dedicate himself as a landscape artist. . . . He has proved to be an accomplished art student and assumed an obligation to the necessary studies and practical exercises to his particular field of art in the manner prescribed. . . and has dedicated himself to the rules in all phases of the Academy in every manner." Facsimile of certificate issued by the Art Academy of Düsseldorf and facsimile of the translated text, January 11, 1873, Thomas Allen archival file, San Antonio Library, Texana Collection.

14 Pinckney, 185.

15 Robertson, 17–18.

16 Gerdts, 46.

17 White, 318.

18 Martha Utterback, *Early Texas Art in the Witte Museum* (San Antonio: Witte Museum, 1968), 48.

19 Steinfeldt, 6.

20 "Thomas Allen, Artist, Dies Suddenly at 74," *New York Times*, August 27, 1924, 17.

21 Gerdts, 46.

22 Steinfeldt, 6.

23 In a letter from 1880, Whitney writes, "My daughter became engaged to an American artist, living for the time at Ecouen, a few miles away. The marriage is expected to be here [Cambridge] next June and the young couple will return to Ecouen in the fall. We were head over heels in excitement." He expanded on the story in a letter dated 1882: "She [Eleanor] was married to a man, whom we all soon learned to love, a young artist, son of a very noble and influential man, Thomas Allen of St. Louis, one of the finest types of an American. . . ." Anna Lee Ames Frohlich, "Thomas Allen Junior and his Lady Eleanor," *Colorado History, Western Footprints*, last modified March 20, 2012, http://coloradogambler.com/western-footprints-thomas-allen-jr-his-lady-eleanor/.

24 Ibid.

25 Up until that point, he had gone by Thomas Allen Jr.; following his father's death he dropped the suffix "junior" from his name.

26 In another letter, Josiah Whitney describes the turmoil of those few days: "Then came a telegram that my daughter was in the gravest danger and she, dear, lovely girl, followed her mother only a few hours later neither having known anything of the other's condition." Anna Lee Ames Frohlich, "Thomas Allen Junior and his Lady Eleanor."

27 Josiah Whitney named Lake Eleanor in Yosemite National Park for his daughter. Peter Browning, *Yosemite Place Names: The Historic Background of Geographic Names in Yosemite National Park* (Great West Books, 2005), 42.

28 Gerdts, 117.

29 Thomas Allen Jr. (1887–1965), Eric who died at six months, Robert Fletcher (1892–1903) who died at age eleven, and Dorothy Fletcher (1898–1921) were Allen's children with Ranney. Undated biographical typescript.

30 Robertson, 17.

31 He was the chairman of the art commission of the city of Boston from 1910 to 1924, president of the Paint and Clay Club, president of the Boston Society of Watercolor Painters for over thirty years, vice president and trustee of the Massachusetts Horticultural Society, and a member of several country clubs.

32 With ties to the family railroad business, the MacAllen Company manufactured "a great variety of insulating material, including railway line equipment, gas fittings, arc lamp insulators, joints for air-brake apparatus, fixture joints, canopy insulators, steam insulators, etc." "The New Factory of the MacAllen Company," *Transit Journal* 28 (1906): 590. Also see, "Thomas Allen Obituary," *The Art News*, September 13, 1924, 6.

33 He became a member of the Museum School Council in 1884 and served as chairman from 1912 to 1924. H. Winthrop Peirce, *History of the School of the Museum of Fine Arts Boston 1876–1930* (Boston: Museum of Fine Arts, 1930), 89–90.

34 "Thomas Allen, President of the Museum," *Museum of Fine Arts Bulletin* (Boston: Museum of Fine Arts, 1924), XXII, 38.

35 Allen died while waiting on a report on the condition of his heart in a Worchester, Massachusetts, hospital. He was 74 years old. "Thomas Allen Obituary," *The Art News*, September 13, 1924, 6.

36 "Thomas Allen," *Museum of Fine Arts Bulletin* (Boston: Museum of Fine Arts, 1924), XXIII, 6–7.

37 Ibid.

38 One can image Allen slipping these botanical samples into these books, where they have been preserved for almost 150 years.

39 Robertson, 18.

40 Ibid, 19.

41 Sam DeShong Radcliffe, *Painting Texas History to 1900* (Austin: The University of Texas Press, 1992), 88.

42 "A Find in Texas Art," *San Antonio Express*, December 18, 1932.

43 Anna Lee Ames Frohlich, "In St. Louis, Thomas Allen Brings Forth the Pacific Railroad," *Colorado History, Western Footprints*, last modified November 22, 2011, http://coloradogambler.com/western-footprints-in-st-louis-thomas-allen-brings-forth-the-pacific-railroad/.

44 United States Congress, "Memorial Addresses on the Life and Character of Thomas Allen, (a Representative from Missouri): Delivered in the House of Representatives and in the Senate, Forty-Seventh Congress, First Session" (U.S. Government Printing Office, 1884), https://archive.org/details/memorialaddresse00unitg, accessed March 17, 2014.

45 *San Antonio Express*, January 16 and February 20, 1877, as quoted in Ron Tyler, "San Antonio in 1886," in *Texas Bird's Eye View*, http://www.birdseyeviews.org/, (Fort Worth: Amon Carter Museum of American Art last modified 2005).

46 The Galveston hurricane of 1900 was one of the deadliest natural disasters in American history. An estimated 6,000 people were killed on the island. David G. McComb, "Galveston, TX," *Handbook of Texas Online*. http://www.tshaonline.org/handbook/online/articles/hdg01), published by the Texas State Historical Association.

47 Tyler, "San Antonio in 1886."

48 Gerdts, 117.

49 Anna Lee Ames Frohlich, "Thomas Allen's Masterpiece of the Market Plaza," *Colorado History, Western Footprints*, last modified February 7, 2012, http://coloradogambler.com/western-footprints-thomas-allens-masterpiece-of-the-market-place/.

50 This title, written by the artist in his sketchbook, suggests that Allen did not exhibit a fluent command of the French language; however, his attempt at using a French title implies that he was, in part, filtering his Texas experience through his European studies and adventures.

51 This historic landmark played a role in the Texas Revolution when Antonio López de Santa Anna flew a red flag from San Fernando to signal to the Texans at the Alamo that they would be shown no mercy. When Allen arrived in 1877, San Fernando had recently been renovated and served as the cathedral for the newly formed Diocese of San Antonio. Ann Graham Gaines, "San Fernando Cathedral," *Handbook of Texas Online*, http://www.tshaonline.org/handbook/online/articles/ivs01, published by the Texas State Historical Association.

52 Mary Ann Noonan Guerra, *The History of San Antonio's Market Square* (San Antonio: The Alamo Press, 1988), 9.

53 Ibid. In 1890, the San Antonio City Hall was built on the site of the Market Plaza, and the open air markets moved elsewhere. Nevertheless, San Antonio cuisine was so well loved that the 1893 World's Fair in Chicago hosted a booth titled, "The San Antonio Chili Stand." Perhaps Allen sampled the fare when he served as judge of awards, remembering his time in San Antonio fifteen years earlier.

54 Gerdts, 117.

55 "Colorful Days Recalled," *San Antonio Express*, February 13, 1936.

56 The painting was given to the library in 1936 by Allen's daughter Eleanor. "Early Days in San Antonio," *San Antonio Express*, February 16, 1936.

57 Gilberto R. Cruz, "San José y San Miguel de Aguayo Mission," *Handbook of Texas Online* http://www.tshaonline.org/handbook/online/articles/uqs23.

58 Dew Joe S. Graham, "Texas-Mexican Vernacular Architecture," *Handbook of Texas Online* http://www.tshaonline.org/handbook/online/articles/cbtut.

Contributors

Ron Tyler is the retired director of the Amon Carter Museum of American Art in Fort Worth, Texas. He has written extensively on American and Western American art and history and is currently at work on a study of nineteenth-century lithographs relating to Texas.

Mario L. Sánchez is an architect and historian with the Texas Department of Transportation. He also writes about the history and architecture of the Texas/Mexico borderlands and is a contributing author to *Buildings of Texas* (2013), a publication sponsored by the Society of Architectural Historians and published by the University of Virginia Press.

David Haynes, a San Antonio-based independent researcher and the former director of production at the Institute of Texan Cultures, is the author of *Catching Shadows: A Directory of 19th-Century Texas Photographers*, published by the Texas State Historical Association.

D. Jack Davis is former dean and professor emeritus of the College of Visual Arts and Design at the University of North Texas. He received the Lifetime Achievement Award from the Center for the Advancement and Study of Early Texas Art (CASETA), and he has collected silver for more than forty years.

Heather Elizabeth White served as a museum educator for the Museum of Fine Arts, Houston, and she is currently a Ph.D. student at the University of Oklahoma, where her focus is the art of the American West.

Bayou Bend house and gardens. Photograph by Rick Gardner; donated in memory of Mary Gardner.

Photograph Credits

Foreword
Bonnie A. Campbell
Photo of Ima Hogg and David B. Warren: MS21-070-001, Ima Hogg Papers,
The Museum of Fine Arts, Houston, Archives.

The Arts in Early Texas: A Cultural Crossroads
Ron Tyler

Fig. 1: Courtesy of the Museum of Fine Arts, Houston
Fig. 9: *The Course of Empire: Destruction*, by Thomas Cole, 1836, oil on canvas, 39 1/4 x 63
1/2 inches; negative #6048; acc #1858.4; Collection of The New-York Historical Society
Fig. 13: © The Museum of Fine Arts, Houston, Thomas R. DuBrock, photographer
Fig. 15: Courtesy State Preservation Board, photograph by Perry Huston, 7/28/95, post conservation.
Fig. 16: Holley (Mary Austin) Papers, di_04685, The Dolph Briscoe Center for American
History, The University of Texas at Austin
Fig. 17: Courtesy of the Witte Museum, San Antonio, Texas
Fig. 19: Bryan (James Perry) Papers, di_04428, The Dolph Briscoe Center for American
History, The University of Texas at Austin
Fig. 24: © The Museum of Fine Arts, Houston, Thomas R. DuBrock, photographer
Fig. 25: Petri (Friedrich Richard) Papers, di¬_02536, The Dolph Briscoe Center for American
History, The University of Texas at Austin
Fig. 26: Petri (Friedrich Richard) Papers, di_04892, The Dolph Briscoe Center for American
History, The University of Texas at Austin

Settlers, Artisans, and Immigrants:
Evolution and Cultural Continuity in the Building of South Texas
Mario L. Sánchez

Figs. 1–3, 9–11, 15, 17–18, 20–21, 23–26, and 28–30: Photos by and courtesy of Mario L. Sánchez

Fig. 4: Blake (Robert Bruce) Papers, CN06475, The Dolph Briscoe Center for American History, The University of Texas at Austin

Fig. 5: Historical Heritage of the Lower Rio Grande, CN06457, The Dolph Briscoe Center for American History, The University of Texas at Austin

Fig. 6: Texas Historical Commission

Fig. 7: © The British Library Board. All Rights Reserved 03/21/2014, Additional MS 17,657

Fig. 8: The Texas A & M University Press

Figs. 12–13: Photos by and courtesy of Stephen Fox

Fig. 14: Runyon (Robert) Photograph Collection, RUN02074, The Dolph Briscoe Center for American History, The University of Texas at Austin

Fig. 16: University of Texas at San Antonio Libraries Special Collections, MS 362:072-0330

Fig. 19: William H. Emory, *Report on the United States and Mexican Boundary Survey made under the Direction of the Secretary of the Interior*, 1857, CN06499, The Dolph Briscoe Center for American History, The University of Texas at Austin

Fig. 22: Historic American Buildings Survey, National Park Service, U.S. Department of the Interior

Fig. 27: Sanborn Map Company

The Search for Early Texas Silversmiths
D. Jack Davis

Figs, 12, 14, 16–18: Photos by David Wharton

Fig. 13: © The Museum of Fine Arts, Houston, Thomas R. DuBrock, photographer

Fig. 15: © The Museum of Fine Arts, Houston

Have Camera, Will Travel:
Itinerant and Immigrant Photographers in Early Texas
David Haynes

Fig.1: Louis-Jacques-Mandé Daguerre (1787-1851). Boulevard du Temple. c. 1838. Original
 destroyed, copy file downloaded from http://upload.wikimedia.org/wikipedia/commons/
 d/d3/Boulevard_du_Temple_by_Daguerre.jpg.
Fig. 12 Houston Public Library, HMRC
Fig. 13: Copy courtesy of University of Texas at San Antonio Libraries Special Collections
Fig. 15: Texas State Library and Archives Commission, Austin, Texas
Fig. 16: Courtesy of the Witte Museum, San Antonio, Texas
Fig. 25 and frontispiece: Copy courtesy of University of Texas at San Antonio Libraries
 Special Collections

Thomas Allen's Sketches and Paintings of Texas, 1877–1879
Heather Elizabeth White

Fig. 1: Courtesy of the Witte Museum, San Antonio, Texas
Fig. 2: Courtesy of the Museum of Fine Arts, Boston, photograph © 2014 Museum of
 Fine Arts, Boston
Figs. 3–4, 7–17, 20–28: Courtesy of Bobbie and John Nau Collection of Texas Art
Figs. 5–6: Courtesy of Anna Lee Ames Frohlich
Fig. 18: Courtesy of Daughters of the Republic of Texas Library at the Alamo,
 gift of Gail Tritch Thomas, SC9995.4.5
Fig. 19: Courtesy of the Hunter Museum of American Art, Chattanooga, Tennessee,
 gift of Berniece and Henry Blount, Jr., HMAA.1993.37

Front cover: © The Museum of Fine Arts, Houston, Thomas R. DuBrock, photographer

Back cover: © The Museum of Fine Arts, Houston, Thomas R. DuBrock, photographer

Bayou Bend Collection and Gardens at the Museum of Fine Arts, Houston, has made every effort
to contact all copyright holders for images reproduced in this book. If proper acknowledgment has
not been made, we ask copyright holders to contact the Museum. We regret any omissions.